The clay strained and refined
Softer than cotton
The wheel kicked by the foot turns by itself now
One thousand vessels in a flash
Dishes, bowls, jars—all round and round

— A poem by Yi Hagon (Damheon) (1677-1724)
 Written in Bunwon the royal kiln where he stayed to fire tomb stones in 1709

Baekja

Korean Traditional Porcelain

Korean Craft & Design Resource Book 06

Ministry of Culture, Sports and Tourism
Korea Craft & Design Foundation

Remarks

- The publication of the book *Baekja: Traditional Korean Porcelain* is a part of "Publishing Project of the Korean Craft & Design Resource Book Series", sponsored by the Ministry of Culture, Sports and Tourism, and conducted by Korea Craft & Design Foundation.
- Names of artifacts and craft works are labeled in order of usage, pattern, period, material, measurements and possessor.
- The terminology are given in Romanized Korean and English.
- Photos were taken by photographer Seon Yumin. Sources of the photos of other origins are cited separately.
- The following is a list of some key terms with their respective meanings that the readers will encounter frequently in this book.
 - *baekja*: high-fire porcelain which is usually white
 - *buncheong ware*: high-fire stoneware which is usually brown
 - *cheongja*: high-fire green-glazed stoneware
 - *onggi*: low-fire ceramic ware which is usually reddish-brown
 - *wagi*: low-fire ceramic ware which is usually unglazed and gray. Because the texture and color of wagi is similar to that of roof tiles, it is called wagi whose literal translation is "roof tile vessel".
- Notes in the brackets ([]) indicate the translator's notes in this book.
- Below is the list of abbreviations in this book.
 - ca. circa
 - cm centimeter (1cm=0.393inch)
 - diam. diameter
 - h. height
 - m meter (1m=39.3inches)
 - OAH overall height

From the Publisher

Korean Craft and Design Resources Series published by the Korea Craft & Design Foundation provides a repository of knowledge and information regarding traditional Korean craft and techniques. It was intended not only for those already familiar with the subject matter but also for laypeople. Starting with *Najeon: Korean Nacre Lacquerware* (2011), the Foundation so far has published the following books: *Traditional Natural Dyeing* (2012), *Somok: Korean Traditional Joinery* (2013), *Jangseok: Korean Traditional Metalwork for Joinery* (2013), *Hanji: Korean Handmade Paper* (2013). This year we are very pleased to publish two more in the same series—*Baekja: Traditional Korean Porcelain* and *Nubi: Traditional Korean Quilting*.

Korean porcelain, known as *baekja* in Korean, developed around the royal family. Influenced by Neo-Confucianism it carries a unique Korean mentality of discipline and elegance. *Baekja: Traditional Korean Porcelain* intends to offer an opportunity to cherish Korean porcelain and extend such an opportunity to a larger audience. A number of experts have been consulted in this process. This book is intended to help the understanding of the past and present of Korean porcelain. It is our hope that this book contributes to the continued presence of Korean porcelain in the present as a contemporary ware. We would like to express our sincere gratitude to those who have contributed to this book: Master ceramists and expert learners, artists and designers working in porcelain, museum staff, the authors, the editing board, and the advisory board. We hope that this book reaches not only artists in the field but also many of those who are interested in preserving the tradition of Korean porcelain.

Nov. 2014
Choi Jeungcheol
President, Korea Craft & Design Foundation

Recommending This Book

"A Rare Book"

This is a rare book in that it is about Korean ceramics. But this small book is truly rare for its excellent content.

This book is the product of rare endeavor: collaboration between two art historians of Korean ceramics and a contemporary ceramic artist. It provides an uncommon opportunity to learn about the history of Korean porcelain in a highly organized manner.

The authors who have in-depth knowledge of the subject matter point out the essential aspects of Korean porcelain in each part and present them in a succinct manner. In short, the authors tell the readers everything about Korean porcelain: its meaning, its techniques, its function, its aesthetics and connoisseurship in each period of time, etc. Most of the historical books on porcelain conclude with the end of Joseon dynasty. However, this book goes beyond that period and discusses the following issues: the diminishment of porcelain and the enforced change it underwent during the turn of the 20th century and under the Japanese occupation, the inevitable modification of porcelain as it was exposed to Western porcelain in recent times, and the effort to preserve the tradition. It is such a rare occurrence to survey the entire one thousand years of Korean porcelain in one book. Also admirable is the fact that relevant photos were selected with such high standards and insight. They maximize educational effect. Rarely do we see that a new set of photos are taken exclusively for one book.

I would like to extend my sincere gratitude to everyone who devoted themselves to this book and I wholeheartedly recommend this book to anyone who loves Korean ceramics.

<div align="right">

Nov. 2014
Kim Jaeyeol
Member, Movable Cultural Heritage Subcommittee
Cultural Heritage Committee

</div>

Preface

We humankind have made ceramic ware ever since we discovered fire. Although most countries have their own tradition of ceramics, the tradition and meaning of porcelain are even more significant in East Asia, the birth place of porcelain.

In the 15th century, Korea was the only country along with China that could produce porcelain. Even Japan was not able to produce porcelain until the Japanese invasion of Korea (1592-1598). At that time porcelain was an exotic item for the Europeans who had just opened the Age of Discovery. They aptly called it "white gold." In addition, at this time the Chinese and Japanese porcelain wares were exported overseas and gained popularity. While Korea did not produce export ware, it kept its own distinct tradition of porcelain (*baekja*) which developed around the royal family for hundreds of years. Porcelain in the Joseon dynasty was inspired by Neo-Confucian values of thrift and discipline. As a result, Korean porcelain is solemn and rigorous rather than being opulent, in which sense it may be said to have maintained the most authentic form of East Asian porcelain. Korean porcelain has its own unique place in the world of porcelain.

Baekja: Traditional Korean Porcelain is intended to offer a "bird's eye view" of Korean porcelain. In this book you will find everything about the Korean porcelain: the definition, types, the history of porcelain (ancient to contemporary), materials and equipment, manufacturing process, etc. The information in this book is based on the study of relevant literature, interviews with experts, and observation of the Korean porcelain studios. To help readers' understanding, a wealth of image resources (photos, drawings, floor plans, etc.) has been included.

Baekja: Traditional Korean Porcelain is divided into four chapters. The first chapter, "Korean Porcelain: An Introduction", discusses the following topics: the definition of porcelain; the conceptual difference between Eastern and Western ceramics derived from different traditions; types of porcelain determined by the decorative method and function; and the history of porcelain, including the start of high-fire ware in Korea in 9th-10th century, we divided the periods into Goryeo, early Joseon, mid-Joseon, late Joseon, modern Korea, and contemporary Korea.

The second chapter, "Materials and Tools for Making Porcelain", presents the raw materials, tools, and kilns which are required for making porcelain. Unfortunately, we had to depend solely on literature to research the

materials used for traditional Korean porcelain. Furthermore, traditional kilns, workshops, and equipment were either discontinued or underwent a drastic modernization under the Japanese occupation. With the scarcity of resources, we did our best to verify information through ancient literature, archeological findings, and analytical data of chemical compositions of Joseon porcelain, while using the clues offered by materials, tools, and workshops used for making modern porcelain.

The third chapter, "Making Porcelain", presents the process of porcelain making with porcelain bowls with a cobalt-blue peony design as a model. The typical process of making porcelain consists of four stages: raw material preparation, shaping, decoration, and firing & finishing. Depending on the vessel shape and design there are variations in the shaping and decorating stages. Other topics covered in this chapter include raised carving technique, inlaying technique, and the so-called *eopdaji* method in which two bowls are fitted together to produce moon jars.

The fourth chapter, "Enjoying Korean Porcelain", presents a variety of porcelain from the past and the present. Porcelain of the past includes Joseon porcelain designated as national cultural property and representative functional porcelain objects. Contemporary porcelain artists whose works have been listed in this chapter may be classified into three types: (1) artists (mostly those designated as Intangible Cultural Heritage or Master ceramist) who maintain tradition with traditional raw materials, technique, and shape; (2) artists who introduce a contemporary twist in shape and decoration while maintaining traditional materials and technique; and (3) artists who create a new tradition by adopting new materials and technique based on contemporary aesthetics.

Notwithstanding its modest size, this book was intended to be everything about Korean porcelain. We hope that this book contributes to the understanding of the past and the present of Korean porcelain and continuing the tradition. Lastly, we would like to thank those who have graciously agreed to perform demonstration as well as those who provided invaluable resources for this book.

Contents

Chapter 4.
Enjoying Korean Porcelain

Reference

Chapter 1.
Korean Porcelain:
An Introduction

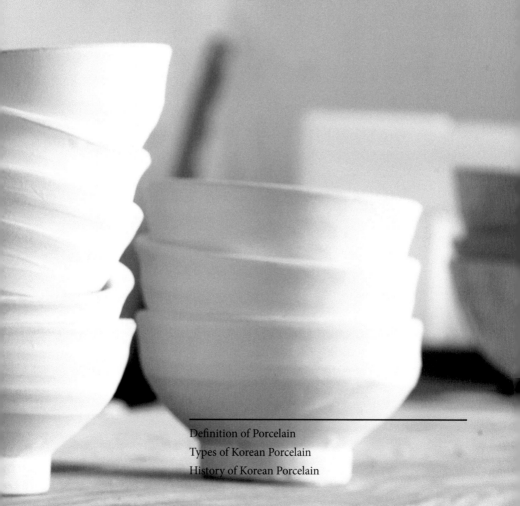

Definition of Porcelain

What is Porcelain?

Porcelain or white porcelain, known as *baekja* in Korean, is produced by forming a vessel with highly refined clay, applying translucent glaze to the shaped clay and firing the vessel at a temperature higher than 1250°C. It is noted for its whiteness and glaze as well as its hardness. It is made with the most pure clay, for which reason it is the most refined porcelain from a traditional standpoint.

In Korea a kaolin type of clay, commonly called "white clay" (*baekto*, white soil) was used for building the body. Compared with the clay used for celadon, known as *cheongja* in Korea, kaolin has a higher content of silica (SiO_2) and alumina (Al_2O_3) as main components in addition to having a lower content of impurities. The glaze, although initially devoid of color, can take on a distinct tone of glaze and texture depending on such factors as trace ingredients, firing temperature, and the atmosphere of the kiln.

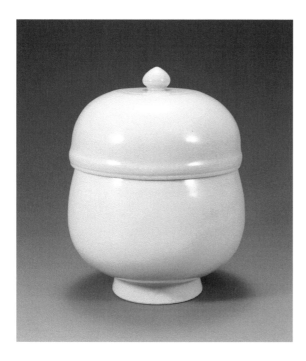

Lidded Jar, early Joseon,
Porcelain, OAH. 22.7cm,
Horim Museum, Treasure no. 806

Classification of Ceramic Ware and Porcelain

East

In the East ceramic ware is distinguished into (1) low-fire ware (*dogi, jil-geu-reut*) which uses clay with a high degree of impurity and is fired at a low temperature and (2) high-fire ware (*jagi, sagi-geu-reut*) which uses highly refined clay and is fired at a high temperature. *Baekja* is the most refined type among high-fire wares.

Eastern classification	low-fire ware (*dogi*)	high-fire ware(*jagi*)
product	terra-cotta, *dogi* , *wagi* , *onggi*	celadon, *buncheong* ware, porcelain
clay	mainly 2nd clay (high plasticity)	mainly 1st clay (low plasticity)
method of shaping clay	ring method, coiling method, paddling method, etc.	throwing on a wheel, slab building, slip casting, etc.

West

In the West after the industrial revolution ceramic ware is classified into terra-cotta, earthenware, stoneware, and porcelain depending on the type of clay used and the firing temperature. Porcelain is the equivalent of Korean *baekja*.

Western classification	terra-cotta	earthenware	stoneware	porcelain
product	reddish brown ware	white earthenware	coarse high fire	pure white porcelain
firing temperature	approx. 800°C	900~1100°C	approx. 1200°C	over 1250°C
absorption rate	15~20%	5~15%	1~5%	0~1%

How to Name Ceramic Ware

Ceramic ware is named according to certain rules except for the occasion in which a potter gives a special name to his pottery. Therefore, names serve as a good reference to the kind of pottery that is being discussed. The first step in naming ceramic ware is giving a name based on the material that determines whether the ceramic ware is white or non-white. Then names indicative of the particular decoration method, decoration motifs, and types or forms are used respectively. For example, "porcelain jar with an iron-brown design of grapes and monkeys" refers to a porcelain jar with an iron-brown design of grapes and monkeys under the glaze.

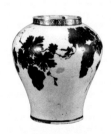

Jar with Design of Grapes and Monkey, late 17th-18th century, Joseon, Porcelain with underglaze iron-brown, h. 30.8cm, National Museum of Korea, National Treasure no. 93

Perfect porcelain such as is found in modern days was first manufactured in China in the 14th century. Korea acquired the Chinese technique and perfected its technique in the 15th century, which in turn was brought to Japan. By the 17th century the three East Asia countries of Korea, China, and Japan were all in the era of porcelain.

During the Japanese invasion of Korea in the 16th century (1592-1598) Japan kidnapped hundreds of Korean potters, which along with the discovery of the Arita kaolin deposits by the Joseon potter, Yi Sampyeong, finally led Japan to manufacture porcelain on a larger scale. By the mid-7th century Japan was no longer under the influence of Korean pottery and converted to the Chinese ceramic system which emphasized mass production and decoration. As the Chinese export ware of the Jingdezhen diminished during the chaotic transitional period between Ming and Qing dynasties, Japan began to export Arita porcelain to Europe, which drew a lot of attention.

Just as Chinese celadon ware reached as far as Turkey and Egypt in the 9th century, the porcelain of East Asia during the 16th-18th century reached the whole European continent via West Asia, Egypt, the Netherlands, Germany, and Great Britain. Ali Ekber Hıtai of the Ottoman Turk

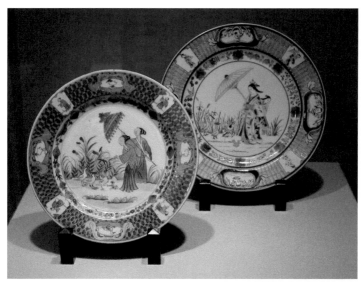

Chinese (left) and Japanese (right) Porcelain Ware to Be Exported to Europe,
1730-1740, h. 2.0cm (left) and 3.5cm (right), The Kyusu Ceramic Museum in Japan

Empire who traveled to China in the early 16th century makes the following statement in his book *Khitay-nameh* (*Book of China*, 1516): "The porcelain of China removes impurities and toxins of food; it is durable and resistant to change. Eating and drinking with a porcelain container is rejuvenating." As revealed in Ali Ekber's praise, the porcelain of East Asia was the object of envy for people in West Asia and Europe in these times.

Iznik Plate with Decoration Imitating Chinese Porcelain with a Cobalt-blue Design, 16th century, h. 5.6cm, rim diam. 33.6cm, Sadberk Hanim Museum, Turkey

The porcelain of East Asia introduced to the West was considered very valuable and rare. Not only West Asia and Europe but also the central and southern Americas began to manufacture replicas of East Asian style porcelains such as those of China and Japan. Starting in Italy of the 16th century with the Medici family who patronized the Medici Porcelain, countries throughout Europe with their respective governments and royal families as patrons were in fierce competition over the production of porcelain throughout the 17th century.

Delftware of the Netherlands is an instance of this. With the manufacture of porcelain by alchemist Johann Friedrich Böttger in Meissen of Germany in circa 1710, Europe finally entered the period of porcelain.

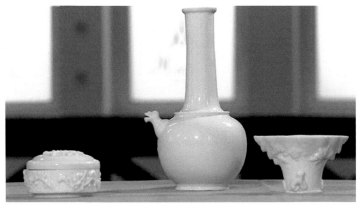

The First European Porcelain Ware, Meissen Porcelain, ca. 1710, Germany

Types of Korean Porcelain

Based on the Decorating Method

Porcelain is classified based on the decorating method. The decorating methods for porcelain may be roughly divided as follows: (1) carving method which employs carving but not coloring, (2) painting method which paints decorations under and over the glaze, and (3) inlaying method which combines the merits of carving and painting methods. While porcelain is bright in color due to a high degree of purity, its clay has low plasticity. For this reason painting method of decoration is suited for porcelain while carving method is more suited for celadon and *buncheong* ware. Understandably, the porcelains that predominated in the Joseon dynasty were without any decoration, and those with decoration were underglazed. While Joseon dynasty produced a number of porcelain with underglaze decoration in cobalt-blue and iron-brown, it did not produce porcelains with overglaze decoration, which paints a lavish design on the surface of the glaze that melts at a low temperature, as seen in Chinese and Japanese porcelains.

Types of Decorating Methods

underglaze decoration	combination (underglaze and overglaze) decoration	overglaze decoration
Designs are painted before the application of glaze. Designs are clear, translucent, and show depth because they are seen through the glaze. However, the number of colors to be achieved is limited as only mineral pigments that do not evaporate at a high temperature during firing can be used.	Some parts of designs such as outlines are painted with underglaze painting technique before glazing and firing. Once the vessel has been fired, the rest of the designs are expressed with overglaze painting technique. This method was practiced in the transitional period of the Chinese Ming but was not very popular.	First, glaze is applied on the dried vessel. Then designs are painted by using pigments that adhere to the surface at a low temperature. This technique allows colorful designs because the choice of suitable pigment is large. However, it has such disadvantages as having to fire a vessel several times and non-vitreous designs that come off very easily.

underglaze decoration diagram: clay, glaze, pigment

combination decoration diagram: clay, pigment, pigment, glaze

overglaze decoration diagram: clay, pigment, glaze

Pure Porcelain

Pure porcelain is divided into (1) the types without any decoration (*somun baekja*) and (2) the types with carved designs, such as (2a) porcelain with raised decoration, (2b) porcelain with intaglio decoration, (2c) porcelain with openwork decoration, and (2d) figurative porcelain. Among them plain white porcelain without any decoration was the most commonly used and was consistently produced in Goryeo and Joseon dynasties. Porcelain with raised carving, intaglio, openwork, and figurative porcelain were mainly produced in the latter period of Joseon dynasty when the production of porcelain reached its peak and was widely used by common people.

Pure Porcelain, Water Dropper, 17th century, Joseon, Porcelain without decoration, h. 6.4cm, Gyeonggi Ceramic Museum

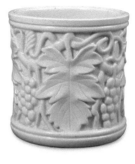

Raised Decoration, Brush Holder with Decoration of Grapes, 19th century, Joseon, Porcelain with raised carving technique, h. 13.5cm, National Museum of Korea

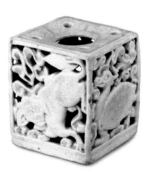

Openwork Decoration, Brush Holder with Decoration of Animals, Joseon, Porcelain with openwork design, h. 14.2cm, National Museum of Korea

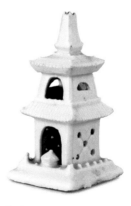

Figurative Porcelain, Pagoda-Shaped Incense Holder, Joseon, h. 10 cm, National Museum of Korea

Porcelain with Inlaying Decoration

Porcelain with inlaying technique, or *sanggam* in Korean, is made by first incising the motif on the surface of the clay body followed by filling in the incised space with clay of a different color. It started to be produced around the same time as celadon with inlaid decoration in Goryeo dynasty and continued until the early Joseon dynasty even though the volume was small. Most of them were inlaid with black slip with high content of iron-oxide, but they soon declined as porcelain decorated with cobalt-blue and iron-brown became more commonplace in Joseon dynasty.

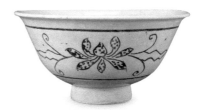

Inlaid Decoration, Bowl with Decoration of Peony Scrolls, 15th century, Joseon, Porcelain with inlaid design, h. 12cm, National Museum of Korea

Porcelain with Underglaze Decoration

Porcelain with underglaze decoration is produced by first drawing a motif on the surface of the body with high-fire pigment and coating it with a highly transparent porcelain glaze. Notable examples include porcelains with underglaze decoration in cobalt-blue, iron-brown and copper-red. Due to a limited color of high-fire pigment in China, Japan, and Europe, overglaze painting technique was often used and the design was overlaid with low temperature pigment or glaze and fired at a low temperature.

Porcelain Classified by the Decorating Method

method	classification	further classification
carving method	pure porcelain	porcelain without decoration, porcelain with intaglio decoration, porcelain with raised decoration, porcelain with openwork decoration, figurative porcelain
combination method	inlaid porcelain	porcelain with black inlaying, porcelain with colored clay inlaying, porcelain with linear inlay, porcelain with planar inlay
painting method	porcelain with overglaze decoration	famille-verte, famille-rose porelain, porcelain with gold-painted decoration
	porcelain with underglaze decoration	porcelain with a cobalt-blue decoration, porcelain with an iron-brown decoration, porcelain with a copper-red decoration, porcelain with polychrome decoration

Porcelain with a Cobalt-blue Design
and Cobalt-blue Glazed Porcelain

Porcelain with a cobalt-blue design, or simple blue-and-white, is made by first drawing a design with cobalt oxide (CoO), or *cheonghwa*, and glazed. When it is fired, the design takes on blue. Cobalt, also called *hoehoecheong*, was very expensive during the early Joseon dynasty because it was imported from Iran via China. Porcelain with a cobalt-blue design was produced exclusively for the royal family in the early Joseon dynasty, but later it was widely distributed among the aristocrats and even common people.

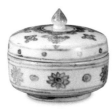

Porcelain with a Cobalt-blue design,
Lidded Bowl with a Flower Design,
18th century, Joseon, Porcelain with
underglaze cobalt-blue design, h. 6.4cm,
National Museum of Korea

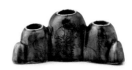

Cobalt-blue Glazed Porcelain,
Inkwell, Joseon, Porcelain painted
with underglaze cobalt-blue, h. 4.4cm,
National Museum of Korea

Porcelain with an Iron-brown Design
and Iron-brown Glazed Porcelain

Porcelain with an iron-brown design is made by first drawing a design with pigment that includes iron oxide (FeO, Fe_2O_3) and is glazed. When it is fired, the design takes on black with blue brown tone. Due to the ease of obtaining the pigment it was produced as early as Goryeo and saw its wide distribution among the commoners after the 17th century in Joseon.

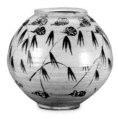

Porcelain with an Iron-brown Design, Jar with
Decoration of Clouds and Bamboo, Joseon,
Porcelain with underglaze iron-brown design,
h. 34.1cm, National Museum of Korea

Iron-brown Glazed Porcelain,
Cylindrical Bottle, Joseon, Porcelain
painted with underglaze iron-brown,
h. 27cm, National Museum of Korea

Porcelain with a Copper-red Design
and Copper-red Glazed Porcelain

Porcelain with a copper-red design is made by first drawing a design with pigment that includes copper oxide (CuO) and is glazed. It is fired in reducing flame, which turns copper oxide into red. Porcelain with a copper-red design was called *jujeom sagi* (porcelain with red spots) or *jinhong sagi* (scarlet porcelain) during Joseon dynasty. Later it was also called "cinnabar *baekja.*" Porcelain with a copper-red design started to be produced in the 12th century Goryeo and became most popular in the 18th-19th century in the late Joseon dynasty.

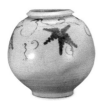

Porcelain with a Copper-red Design, Jar with Decoration of Grapes, 18th century, Joseon, Porcelain with underglaze copper-red design, h. 26.7cm, National Museum of Korea

Copper-red Glazed Porcelain, Lidded Case for Outdoor, 19th century, Joseon, Porcelain painted with underglazeiron-brown, h. 20.1cm, National Museum of Korea

Polychrome Porcelain

Polychrome porcelain is decorated with all three pigments of cobalt-blue, iron-brown, and copper-red. The polychrome porcelain, inspired by Chinese overglaze wares, became very popular in later period of Joseon dynasty. Among the Joseon porcelains it is the most opulent kind. Except for a rare occasion where all the three pigments were used, typically such pairs as 'cobalt-blue + iron-brown' and 'cobalt-blue + copper-red' were used.

Cobalt-blue + Iron-brown, Mountain-shaped Brush Rest, 19th century, Joseon, Porcelain decorated in underglaze cobalt-blue and iron-red, h. 11.5cm, National Museum of Korea

Cobalt-blue + Copper-red, Peach-shaped Water Dropper, 19th century, Joseon, Porcelain decorated in underglaze cobalt-blue and copper-red, h. 8cm, National Museum of Korea

Variety of Designs on Porcelain

Common designs of porcelain include landscape, animals, plants, Chinese characters, and geometrical designs.

landscape design	Eight Views of Xiaoxiang	pine trees, bamboos, and people	animals symbolic of longevity
animal design	clouds and dragon	fish	flowers and birds
plant design	peony	chrysanthemum	orchid
Chinese characters and other designs	壽(su, longevity) and 福(bok, fortune) characters	vines	geometrical design (e.g., swastika, head of ruyi)

Classification by Function and Use

Dinner Ware: for Food and Drink

Dinnerware is intimately involved with the history of human life style. It exhibits a sensitive response to the dining and life style of a given period. Porcelain dinner ware may be divided into two representative kinds. One is the kind that holds liquids (water, wine, and tea, etc.) such as bottles, ewers, and cups. The other is the kind that contains food such as bowls, small bowls, dishes, and tiny bowls.

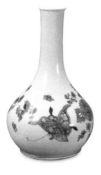

Bottle with Decoration of Chrysanthemums and Butterflies, 19th century, Joseon, Porcelain painted with underglaze cobalt-blue, h. 27.2cm, Gyeonggi Ceramic Museum

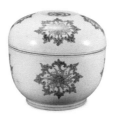

Lidded Blow with Decoration of Floral Medallions, ca. 1857, Joseon, Porcelain painted with underglaze cobalt-blue, h. 15cm, National Museum of Korea

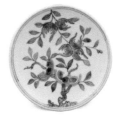

Dish with Decoration of Buddhist Hand and Chestnut Trees, Joseon, Porcelain painted with underglaze cobalt-blue, h. 2.4cm, National Museum of Korea

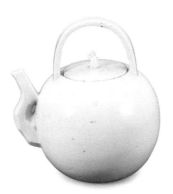

Ewer, 19th century, Joseon, Porcelain, h. 19cm, National Museum of Korea

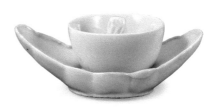

Cup and Saucer Set, 19th century, Joseon, Porcelain, OAH 5.9cm, National Museum of Korea

Kitchen ware is used for cooking, storing, and transporting food. As the name suggests, it is mainly used in the kitchen. *Onggi* was used to make large vessels while porcelain was used for making graters, funnels, rice cake molds, spice jars, small jars, drum-shaped bottle, and turtle-shaped flattened bottles.

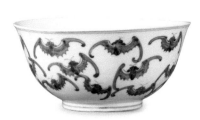

Large Bowl with Decoration of Bats, Joseon, Porcelain painted with underglaze cobalt-blue, h. 19.5cm, National Museum of Korea

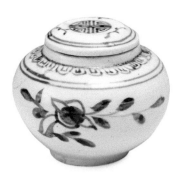

Jar with Decoration of Floral Scrolls, late Joseon, Porcelain painted with underglaze cobalt-blue, h. 11cm, Yanggu Porcelain Museum

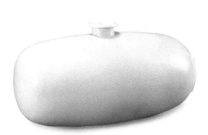

Drum-shaped Bottle, 15th-16th century, Joseon, Porcelain, h. 21.2cm, Gyeonggi Ceramic Museum

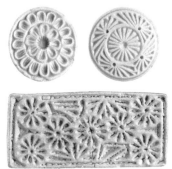

Round Porcelain Rice Cake Mold with Decoration of Flowers, 19th century, porcelain, h. 3cm, Konkuk University Museum (left); 19th century, porcelain, h. 6.9cm, Konkuk University Museum (right)
Rectangular Porcelain Rice Cake Mold with Decoration of Flowers, 19th century, porcelain, h. 5cm, Konkuk University Museum

Ceremonial and Ritual Vessels

Ceremonial and ritual vessels were used for small or large scale banquets, ancestral rites, and auspicious events. Many times porcelain was the choice of vessel for these events. Some of their examples include the jars with a dragon design for royal ceremonies; *bo* (grain vessel), *gwe* (grain vessel), *jun* (jar), *jak* (wine cup), and incense burners for ancestral rites; burial wares and memorial stones for funeral; and a placenta jar that was used to store a new born baby's placenta.

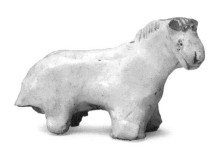

Placenta Tablet with Inscription of "*cheon gye yungnyeon*", ca. 1626, Joseon, Porcelain, h. 4.2cm, National Museum of Korea

Horse-shaped Burial Accessory, Joseon, Porcelain, h. 4.5cm, Yanggu Ceramic Museum. Burial accessory is buried together with the dead in the tomb to console their soul.

Ritual Vessel, Joseon, Porcelain, h. 21cm, National Museum of Korea

Placenta Jar, Joseon, Porcelain, h. 25cm (left), 35.7cm (right), National Museum of Korea. Placenta jar was used to store the placenta of a new born baby in the royal family.

Sarangbang Ware: Containing Stationery and Hobby Equipment

Sarangbang, or men's quarter, refers to a room, where master of the house lives and also used for his study and for hosting a guest. It was a necessary feature in the housing of scholarly and aristocratic classes, and became a common feature even among the commoners by later Joseon dynasty. Representative porcelain objects found in the *sarangbang* include stationery items (e.g., inkstones, water droppers, brush cases, and brushbasins) and hobby equipment (e.g., spittoons, tobacco pipes, go, *janggi* (Korean chess)).

Brush Holder with Decoration of Plum Blossoms and Bats, Joseon, Porcelain with raised design, h. 11.2cm, National Museum of Korea

Lidded Incense Burner with Decoration of a Lion, 19th century, Joseon, Porcelain, h. 15.7cm, Gyeonggi Ceramic Museum

Flower Pot with Decoration of Plum, Pine Tree, and Bird, late Joseon, Porcelain painted with underglaze cobalt-blue, h. 12.5cm, Yanggu Ceramic Museum

Smoking Pipe with a "Su (long life)" Character Design, 19th century, Joseon, Porcelain, h. 5.3cm, Haegang Ceramics Museum

Anbang and Toiletries

Anbang, or women's quarter, literally means an interior (*an*) room (*bang*) and was named so because it was usually a place for the madam of the house who was also called "inside person" The room was the most essential and useful place in a house, also serving as a family gathering place. A variety of vessels were stored in this room which would serve for family life and leisure activities of the madam. Representative porcelain vessels found in *anbang* include a lamp, pillow ends, a lidded facial power bowl, and a facial powder dish.

Lidded Bowl, Goryeo, Porcelain, OAH 3.8cm, National Museum of Korea

Lamp, early 20th century, Porcelain, h. 6cm, Yanggu Ceramic Museum

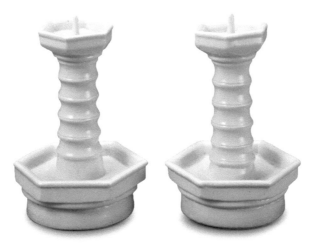

Candlesticks, 19th century, Joseon, Porcelain, h. 18cm, Gyeonggi Ceramic Museum

Miscellaneous Articles

In addition to the range of functions discussed above, there are many porcelain items that were used for a variety of other uses. Examples of its usage in everyday life are the weighing pendulum, and the sun dial. Examples of its industrial application are *godeuretdol* weights used for weaving a straw mat, fishing sinkers, *gatmo* [a part inserted in a kick plate to accelerate the torque of a wheel] and *botgeuk* [a part inserted in a shaping plate to prevent an excessive wear of the wooden plate] which serve as a bearing in a potter's wheel.

Sun Dial with Decoration of Twelve Zodiac Signs, 19th century, Joseon, Porcelain with underglaze cobalt-blue design, h. 6.6cm, Haegang Ceramics Museum

***Godeuretdol* Weight**, early 20th century, Porcelain, h. 6.5cm, Yanggu Ceramic Museum
Godeuretdol is used when knitting a straw blind or a mat to lower the woven part to a certain height.

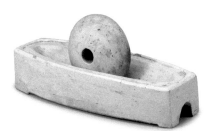

***Yakyeon* (druggist's mortar)**, 18th century, Joseon, Porcelain, h. 6.6cm, National Museum Korea
Yakyeon was used by an oriental doctor to grind medicinal herbs or crush them to extract the juice.

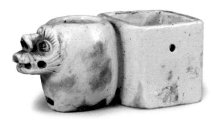

Ink Container, Joseon, h. 5.8cm, National Museum of Korea
It consists of two parts, the part that holds ink and a hexagonal part which stores spools of threads.

History of Korean Porcelain

In an ideal and natural process of development, ceramic ware progresses from the stage of terra-cotta ceramics to that of porcelain ware via that of stoneware. In general, a 7000-year-period of from 6000 BCE (Neolithic Age) through the 8th century AD is typically referred to as the age of ceramic culture. By the end of this period the progress of ceramics had advanced past low temperature lead-glazed ware and high temperature ash-glazed stoneware to the stage immediately before hard-paste porcelain.

Manufacturing vessels using white clay had already started in Yin dynasty of China (1600 BCE-1046 BCE), and porcelain continued to progress past the Sui dynasty (581-618). However, celadon, which was developed earlier, dominated the production of ceramic ware; porcelain began to be produced on a significant scale after the production of Xingzhou ware of the Tang dynasty (618-907). As Ding ware of the Northern Song dynasty (960-1127) and Jingdezhen ware flourished after Yuan dynasty (1271-1368), the production of porcelain was accelerated in China and eventually brought China an international reputation.

Korea started to produce celadon, or *cheongja* in Korean, and porcelaneous ware in the 9th century; yet it was not until the 14th-15th century that porcelain arose as a complete industry. In other words, it took as long as 600 years for Korea to acquire a technique for making porcelain, progressing from celadon built with relatively less pure 2nd clay to true porcelain of 1st clay with placticity and high durability by firing at a high temperature.

Porcelain became a central cultural piece in Korea in the 15th century. This was the time when the Joseon dynasty embarked on building a strong country, and porcelain of completely different materials and shapes was diligently produced along with the inherited celadon and *buncheong* ware. After the15th century in Joseon dynasty porcelain became more popular. While *buncheong* ware went into a rapid decline from the late 15th century, porcelain assumed an absolutely exclusive place in industry and it boasted the finest quality and largest production.

History of Korean Ceramic Ware

Neolithic Age (6000-2000 BC)	• ca. 6000-4000 BC: Production of terra-cotta (terra-cotta without any pattern, raised comb-pattern design terra-cotta) started. • ca. 4000-3000 BC: Comb-pattern terra-cotta was common.
Bronze Age (2000-300 BC)	• Along with the popularity of terra-cotta without any pattern, burnished red pottery terra-cotta and burnished red terra-cotta were produced.
Early Iron Age (300-0 BC)	• Hard-paste gray terra-cotta with paddling technique was produced.
Proto-Three Kingdom period (0-200 AD)	• Along with hard paste gray terra-cotta, coarse and hard gray pottery (*wagi*) was popular.
Three Kingdoms Period (200-667 AD)	• Potter's wheels were used. Bluish gray hard paste terra-cotta was popular. The technique was introduced to Japan. • ca. the 5th century: Terra-cotta in different shapes was produced in Silla and Gaya. • ca. the 6th century: Inkstones and tripod pottery influenced by the southern Chinese dynasties were produced in Baekje.
Unified Silla (668-917 AD)	• 7th-8th century: Influenced by the Buddhist cremation practice, terra-cotta with a stamped design, cinerary urns, and three-colored vessels were produced. • 8th-9th century: A large volume of Chinese tea bowls, such as celadon of Yue ware and white ware of Xing ware was imported.
Goryeo (918-1391)	• 9th-10th century: first Korean celadon (*cheongja*) and white porcelaneous ware (*baekja*) were produced. (The technique for making celadon of Yue ware was introduced to Goryeo.) • 1124: The Chinese envoy Seo Geung (Zu Jing) writes about the "green jade colored celadon" of Goryeo. This was the golden period of celadon. • 12th-13th century: Inlaid celadon was popular. Celadon with scarlet red design and celadon with gold luster were invented. • late 14th century: Due to the Japanese invasion the trite transportation system was paralyzed and the ceramic industry in southern coastal areas suffered.
Joseon (1392-1910 AD)	• ca. 1467: Saongwon's royal kiln was built in Gwangju, Gyeonggi-do to produce porcelain with cobalt-blue design for the government. • 1592-1599: During the Japanese invasion, thousand of masters including masters of ceramic ware were taken to Japan. • 1634: With the scarcity of porcelain with a cobalt-blue design, porcelain with an iron-brown design became popular. • 1752: The royal kiln was moved to the present Bunwon-ri, Namjong-myeon , Gwangju-si, Gyeonggi-do. • late 18th century: With extravagance trend of the time, royal porcelain was frequently smuggled out by the wealthy merchants and investors. • 1884: The royal kiln was privatized.

 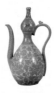

Comb-pattern Terra-cotta	Burnished Red Terra-cotta	Terra-cotta in Different Shapes	Celadon	*Buncheong Ware*

Goryeo Dynasty

In Korea, white soft-paste porcelain, which was inspired by China, began to be produced along with celadon as early as the 9th-10th century. The kilns that produced early soft-paste porcelain were found in places such as Seo-ri, Yongin-si, Gyeonggi-do; Bangsan-dong, Siheung-si; and Jungam-ri, Yeoju-gun in Gyeonggi-do. During the Goryeo dynasty the soft-paste porcelain was produced on a small scale compared to celadon. In early stage, the soft-paste porcelain seems to have been thought of more highly than celadon. However, from the 11th century its quality declined. Its clay contained impurities, the glaze was thinly applied, and the glaze failed to fit the clay body. Deteriorating quality dramatically slowed its production while celadon continued to progress. In some instances, Jingdezhen porcelain imported from China replaced Korean porcelain.

Around the 12th and 13th centuries high quality porcelain with intaglio, raised carving, and inlaying techniques for decoration began to be produced in major kilns (e.g., Buan and Gangjin of Jeolla-do). Although this porcelain was more refined than the previous examples, in general Goryeo porcelain never drew as much attention as celadon did. The shape, decora-

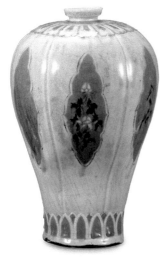

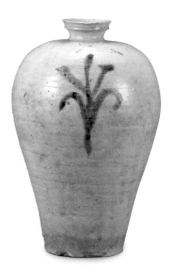

Bottle with a Peony and Willow Tree Design,
12th century, Goryeo, Porcelain with inlaid
decoration, h. 28.8cm, National Museum of
Korea, National Treasure no. 345
The body of the vessel was coated in a white
(or porcelain) slip and black clay was inlaid to
express the motif.

Bottle with a Flowering Plant Design,
Goryeo, Porcelain, h. 26.1cm,
National Museum of Korea

tion motifs, and techniques of Goryeo porcelain are almost identical to those of Goryeo celadon, the only difference consisting in the raw material and glaze. Most of the Goryeo porcelain took on ivory color and soft texture because despite the molten glaze the clay was not transformed enough to be called fine ceramic. This factor contributed to Goryeo porcelain being a less durable and less practical ware compared with celadon.

Despite its weaknesses Goryeo porcelain continued to be produced throughout Goryeo dynasty, maintaining its unique tradition. By the late 14th century it came to have a thick body and glaze in addition to a hard surface, making it comparable to hard-paste porcelain. The technique of Goryeo porcelain was learned by the Joseon potters spurred by the regained popularity of porcelain during Joseon dynasty. Representative kiln sites of Goryeo porcelain are found in Seoksu-dong, Anyang and Bangsan-myeon, Yanggu.

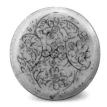 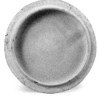

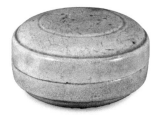

Lidded Bowl with Decoration of Floral Medallions and Vines, 12th-13th century, Goryeo, Soft-paste porcelain with inlaid design, h. 2.7cm, National Museum of Korea

Litted Bowl with Decoration of Lotus Petals, Goryeo, Soft-paste porcelain with intaglio design, h. 3.6cm, National Museum of Korea

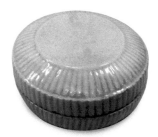

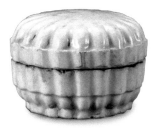

Chrysanthemum-shaped Lidded Bowl, Goryeo, Soft-paste porcelain, h. 5.1cm, National Museum of Korea

Chrysanthemum-shaped Lidded Bowl, Goryeo, Soft-paste porcelain, OAH. 6cm, National Museum of Korea

Early Joseon Dynasty (15th-16th century)

The ceramic wares that represents early Joseon dynasty are *buncheong* ware and porcelain. *Buncheong* ware is an advanced form of celadon which took on regional characteristics as celadon with inlaid decoration spread across the peninsula in the late Goryeo dynasty. Through its various decoration techniques (inlaying, stamping, broad brush stroke, dipping, intaglio, sgraffito, and underglaze iron-brown design) it exhibits various senses of elegance and a wide range of aesthetics. Until the 15th century the royal family of Joseon dynasty used *buncheong* ware offered as a tribute from different regions, which made fine *buncheong* ware such as stamped *buncheong* extremely popular. However, even then some regions (e.g., Gwangju of Gyeonggi-do, Goryeong and Sangju of Gyeongsang-do, and Namwon of Jeolla-do) not only continued to produce porcelain but also offered it to the royal family as a tribute. Most of those kilns inherited the traditional Goryeo porcelain and produced soft-paste plain porcelain and inlaid porce-

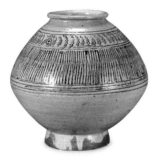

Jar with Decorations of Rows of Dots,
15th century, Joseon, Porcelain with stamped design, h. 18.4cm, National Museum of Korea

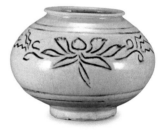

Jar with Decoration of Peony Vines, Joseon, 15th century. Porcelain with inlaid design, h. 12cm, National Museum of Korea

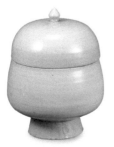

Lidded Bowl, Joseon, 15th-16th century. Plain porcelain, OAH 18.1cm, National Museum of Korea

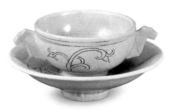

Cup and Saucer with Decoration of Floral Vines, 15th century, Joseon, Porcelain with inlaid design, h. 5.6cm (cup), 4.1cm (saucer), National Museum of Korea

lain. Hard-paste porcelain, a new kind of porcelain introduced from China, seems to have started its production with Gwangju, Gyeonggi-do as the headquarters.

It seems that as early as the reign of King Sejong porcelain with a cobalt-blue design, also known as blue-and-white porcelain, started to be produced using Persian cobalt-blue pigment imported via China. When importing cobalt-blue pigment from China became difficult in the 1460s, potters focused on developing domestic blue pigment (*tocheong*, domestic blue). Because the pigment itself was so precious, the use of porcelain with a cobalt-blue design was exclusively limited to the royal family; common people were prohibited from using it.

In circa 1467 Joseon built a royal kiln in Gwangju, Gyeonggi-do, which was managed by Bunwon (a branch bureau) of Saongwon, to produce porcelain. The government dispatched supervisors along with court painters to the royal kiln so they could contribute to the production of porcelain with a cobalt-blue design. As a result, the royal kiln of the late 15th-16th century produced porcelain of the finest quality of the times. Porcelain with a cobalt-blue design expressing the spirit of Korea was also diligently produced. From the late 15th century the production of porcelain became widespread in the Korean peninsula. Regional kilns, inspired by the production of porcelain of the royal kiln, slowly shifted their focus from the production of *buncheong* ware to that of porcelain. They even built new kilns to exclusively produce porcelain.

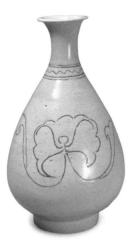

Bottle with Decoration of Peony, 15th century, Joseon, Porcelain with inlaid design, h. 29.6cm, Horim Museum, Treasure no. 807

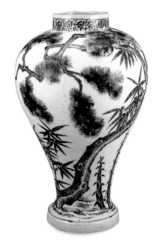

Jar with Decoration of Bamboos and Pines, 15th century (1489), Joseon, Porcelain with underglaze cobalt-blue design, h. 48.7cm, Dongguk University Museum, National Treasure no. 176

Porcelain in the early Joseon dynasty exhibited a high level of integration. While it emulates the porcelain ware of the Chinese Ming dynasty, it exhibits a high level of cohesiveness through a simple and concise sculpting technique. A similar trend is witnessed in porcelain with cobalt-blue designs. At the beginning the Joseon potters of porcelain with cobalt-blue designs merely imitated the porcelain with cobalt-blue designs of late Yuan and early Ming dynasties of China by arranging accessory motifs, such as a head of *ruyi* and lotus petals (spread of lotus flowers) on top and bottom of the vessel after crowding the center with complex designs. However, with the passage of time the accessory designs came to be either simplified or even omitted while the central decoration became more like a single painting surrounded by negative space.

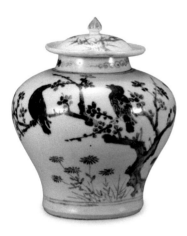

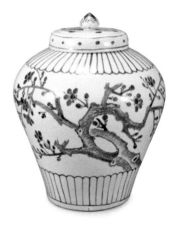

Jar with Decoration of Plum, Bamboo, and Bird, 15th century, Joseon, Porcelain with underglaze cobalt-blue design, h. 16.5cm, National Museum of Korea, National Treasure no. 170

Jar with Decoration of Plum and Bamboo, 15th century, Joseon, Porcelain with underglaze cobalt-blue design, OAH 29cm, Horim Museum, National Treasure no. 222

Literature

1. According to *Joseon Wangjo Sillrok* (*the Annals of the Joseon Dynasty*), in 1425 (7th year of King Sejong reign) when Yun Bong (Yi Feng), the messenger sent to Joseon from the Chinese Ming demanded a large amount of porcelain as a tribute to the Chinese emperor, King Sejong ordered that porcelain be made in Gwangju, Gyeonggi-do with special care and sent to China.

2. According to the book *Yongjaechonghwa* (*A Collection of Stories by Yongjae*) by Seong Hyeon (also called Yongjae), the choice vessel for the king during the reign of King Sejong (1418-1450) and the reign of King Sejo (1455-1468) was porcelain and porcelain with cobalt-blue design, respectively.

The above records attest that Joseon porcelain whose high quality even paralleled the Chinese imperial porcelain was produced in Gwangju as early as early 15th century when King Sejong reigned.

Joseon dynasty was embroiled in three invasions by three different forces (the Japanese, the early Ching, and the later Ching that unified China) in the late 16th century and early 17th century. The wars put most industries including the ceramic industry into depression. During the recovery from war devastation the demand for porcelain for ceremonial and every day purposes was on a steady increase, but due to a lack of resources in production, labor, capital, and facilities the quality of porcelain from both the royal kiln and regional kilns in the 17th century Joseon dynasty was predictably low.

By the 1630s even the royal family began to use porcelain with an underglaze iron-brown design which used inexpensive domestic iron-brown pigment instead of the imported cobalt-blue pigment that was traditionally used for ceremonial vessels.

In addition, the royal kiln mass-produced gray-blue low-quality porcelain with *omokgup* (foot made by carving out the inner base of the foot) and using coarse grains of sand as kiln spurs. The structure of the kiln underwent a complete transformation into a high productivity kiln, i.e., a kiln with several chambers that are partitioned by earthen bricks. This attests to the serious effort the royal kiln made to meet a challenging period of time by implementing a variety of techniques to raise productivity.

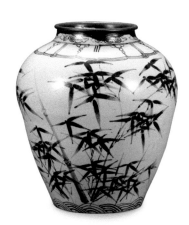

Jar with Decoration of Bamboo and a Plum, late 16th-17th century, Joseon, Porcelain with underglaze iron-brown design, h. 40cm, National Museum of Korea

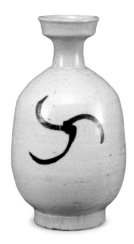

Bottle with Decoration of Three-leaf Plant, 17th century, Joseon, Porcelain with underglaze iron-brown design, h. 23.2cm, Gyeonggi Ceramic Museum

As the economy recovered during the reign of King Sukjong (1661-1720), the operation at the royal kiln also recovered. In the early 18th century Geumsa-ri kiln (1726-1761) produced high quality porcelain that displayed snow white color. Porcelain with a cobalt-blue elegant flowering plant design was also produced at this time. With the high activity level of the royal kiln porcelain with iron-brown design surrendered its dominant position to an earlier dominating ceramic ware, i.e., porcelain with a cobalt blue design and was displaced to local areas. By the late 17th century porcelain was actively produced in local areas and porcelain decorated with simple floral scrolls in underglaze iron-brown became popular throughout the Korean peninsula.

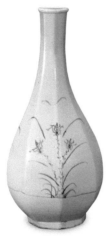

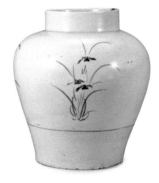

Octagon Bottle with Decoration of Orchid,
early 18th century, Joseon, Porcelain with
underglaze cobalt-blue design, h. 41.1cm,
National Museum of Korea
This bottle is an angular octagonal bottle.
It was a popular shape in mid-Joseon dynasty
with the prominence of the protruding belly
increasing through time.

Jar with Decoration of Orchid, 18th century,
Joseon, Porcelain with underglaze cobalt-blue
design, h. 26.2cm, National Museum of Korea

Literature

According to *Seungjeongwon Ilgi* (*the Daily Records of Royal Secretariat of Joseon Dynasty*) Joseon
dynasty wanted to produce *hwaryongjun* (porcelain jar with a cobalt-blue dragon design) to be used
for a welcoming ceremony for Chinese messengers, but because potters could not obtain cobalt-blue
pigment, they instead used red ocher to make the jar with dragon design. As a matter of fact, shards of
laze iron-brown designs of clouds and a dragon, a vine, a plum and a bamboo were discovered during
this time in the following kiln sites in Gwangju where the royal kiln was operated: Sangrim-ri (ca. 1631-
1636), Seondong-ri (1640-1649), Songjeong-ri (ca. 1649-1653), Yusa-ri (ca. 1660-1664), and Sindae-ri
(1665-1676).

Late Joseon Dynasty (late 18th-19th century)

Porcelain reached its pinnacle in late Joseon when ceramic industry expanded across the peninsular aided by the efficient distribution. At this time Joseon saw the arrival of a class of wealthy merchants with active overseas trade facilitated by the settlement of *Daedongbeop* Reform [a law that allowed the people to submit rice instead of regional specialties as a tax payment to the government]. The Western culture and products introduced through the Chinese Ming dynasty around this time inspired Joseon and brought a new and critical perspective on the domestic state of affairs. This new way of thinking formed the foundation of *Silhak* (practical learning) which led to the cultural renaissance during the reigns of King Yeongjo (1724-1776) and King Jeongjo (1777-1800).

The royal kiln of late Joseon was able to achieve stability in operation by settling down in the present Bunwon-ri, Namjong-myeon, Gwangju in 1752. The settlement was determined by the use of the timber carried down the Namhan River. The production based on the supply of firewood and white clay via the river from Gangwon-do and Chungcheong-do ensured a stable stream of supply. The royal kiln procured its regular supply of high quality white clay from Yanggu, Gangwon-do and the ceramic industry flourished on the Korean peninsula. Inspired by these positive facts, the places which were originally known as white clay suppliers, including Gapyeong, Wongju, Chungju and Jinju, for the royal kiln in Bunwon ventured into their own production of porcelain.

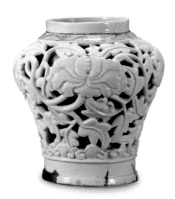

Jar with Decoration of Peony Vine, 18th century, Joseon, Porcelain with openwork design, h. 26.5cm, National Museum of Korea, Treasure no. 240

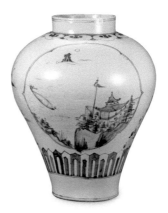

Jar with Decoration of Landscape, late 18th century, Joseon, Porcelain with underglaze cobalt-blue design, h. 37.5cm, National Museum of Korea
It was in late Joseon when the "Eight Views of Xiaoxiang" was painted as a singular landscape painting in a rhombus window. This design is often found in the porcelain produced by the royal kiln.

Private production of pottery was implicitly allowed early on in the royal kiln as a way to tackle a crisis in business management. With the arrival of an investor group consisting of wealthy merchants in the mid- and late Joseon dynasty private production of porcelain ware became more frequent, which eventually led to the circulation of porcelain of the royal kiln in the market.

The royal kiln continued its production in Bunwon-ri for approximately 130 years until it was sold in 1884 to a private investor due to the problems related to private production of porcelain and the pressure from the distribution of imported porcelain. The economic success and the lively market of late Joseon along with the stability of the royal kiln inspired the regional production and distribution of porcelain. As a result, porcelain was consistently produced throughout the peninsula from Jeolla-do, Chungcheong-do, Gangwon-do, Hwanghae-do to Pyeongan-do.

The royal kiln also diligently produced porcelain with a cobalt-blue design which reflected the aesthetics of the royal family and aristocrats, leading to the production of vessels of unprecedented size that exuded confidence. In addition, as polychrome porcelain was imported from China and Japan through private trade and gained popularity, porcelain with luxurious decoration using cobalt-blue, iron-brown, and copper-red pigments along with high quality vessels with a peculiar shape using raised carving technique, openwork and figurative decorative techniques, began to appear.

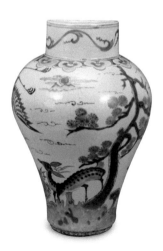

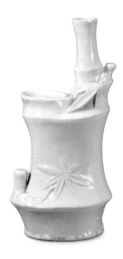

Jar with Decoration of Animals Symbolic of Longevity, 19th century, Joseon, Porcelain with underglaze cobalt-blue and copper-red design, h. 37.3cm, National Museum of Korea

Bamboo-shaped Bottle, 19th century, Joseon, Porcelain with raised design, h. 25.6cm, National Museum of Korea

These pigments and techniques were often used for making everyday vessels (e.g., jars, bottles, and braziers) and stationery accessories (e.g., water droppers and brush holders) in particular.

Such ostentatious articles were considered by the ruling class to be luxury items that threatened the authority of the royal family. As a result, King Jeongjo even issued an edict prohibiting the production of *gapgi* (luxurious vessels fired in a saggar) and *hwagi* (porcelain with a cobalt-blue design, representative luxury ceramic ware along with *gapgi*). However, the demand of aristocrats and the wealthy for new design and art heightened, and prohibiting luxury items ironically led to the blind importation of Chinese and Japanese porcelain ware.

After the reign of King Sunjo (1800-1831) Bunwon-ri began to produce vessels that reflected the need of aristocrats or commoners in addition to those for the royal family and government offices. These vessels were circulated throughout the peninsular by merchant investors. In one instance, porcelain with a cobalt-blue dragon design, a vessel intended to be used exclusively by the royal family, was smuggled out of the palace and was used as a honey jar in a commoner's kitchen. On the one hand, these problems eventually led the porcelain of the royal kiln to fall out of the royal family's favor and the royal kiln to be privatized. On the other hand, these issues contributed to the widespread use of porcelain. By the 19th century regional kilns were in active operation to the extent that porcelain was displayed for sale in as many as eighty markets in the Korean peninsula.

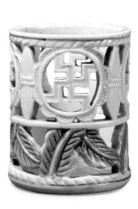

Brush Holder with Decoration of Swastika,
late Joseon, Porcelain with cobalt-blue
and openwork design, h. 12.5cm,
National Museum of Korea

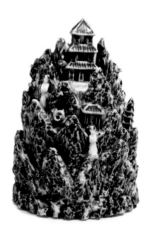

Mountain-shaped Water Dropper,
19th century, Joseon, Porcelain painted
in cobalt-blue and iron-brown, h. 19.1cm,
National Museum of Korea

Following the opening of Korea (1876) and the privatization of the royal kiln (1884) in Joseon dynasty ceramic ware began to be imported from China, Japan, and Europe. In response to the abundance of the Japanese ceramic ware the trailblazer intellectuals of Joseon tried to enlighten people about the importance of the ceramic industry and encourage domestic production of ceramic ware. In an effort to save the domestic ceramic industry, Joseon had the Ministry of Agriculture, Commerce and Industry initiate the establishment of a design and art school with the support of the French embassy in Joseon in 1897 in addition to participating in the Paris International Exposition in 1900.

The Joseon royal family publicly declared a revival of traditional handicraft technique and produced high quality craftwork, which led to the opening of Hanseong Art Factory in 1908. Hanseong Art Factory was later renamed as Yi Dynasty Art Factory in 1910 when the Japanese occupied Korea. Its main production was imitation Goryeo celadon that reflected the aesthetics of the Japanese. In these times celadon drew a great deal of attention as "antique" while porcelain did not because of its commonality.

The porcelain industry shifted its focus to everyday ware for the Japanese who pursued industrialization, leading to the establishment of Daniguchi Ceramic Factory in Goesan (1900), Ito Ceramic Factory in Yeongdeungpo, Ceramic Improvement Association (1913), and Japan Hard-Paste Ceramic Factory in Busan (1917). In addition, the Ceramic Laboratory of

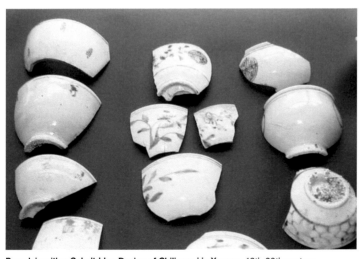

Porcelain with a Cobalt-blue Design of Chiljeon-ri in Yanggu, 19th-20th century

Japanese Government General of Korea was established in Ohak-ri, Yeoju in 1932; which formed the foundation for the continuation and industrialization of Joseon porcelain aided by enforced advanced Japanese techniques. Domestic ceramic ware companies such as Miryang Ceramic, Haengnam Co., and Hankook Chinaware which were founded during the Japanese occupation began to operate their production lines on a large scale to meet the demand of the consumers in the late 1950s when Korea regained some measure of social stability from the devastation of the Korean War.

After Korea achieved independence from Japan it made an effort to continue to revive Goryeo celadon and the Joseon porcelain and established Korea Arts Laboratory (Daebang-dong kiln) and Korea Design and Art Laboratory (Seongbuk-dong kiln) in 1955 and 1956, respectively. However, due to financial difficulty they closed after several years of operation. Afterwards some masters who worked in the laboratories (e.g., Ji Suntaek and Yu Geunhyeong) moved the kilns to Icheon where they continued to produce ceramic ware while other masters (e.g., Yu Gangyeol and Chung Gyu) furthered their studies overseas and taught ceramics in academia.

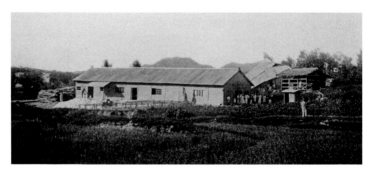

Yeoju Ceramics Common Workspace, the Central Research Laboratory of Colonial Korea, early 1930s

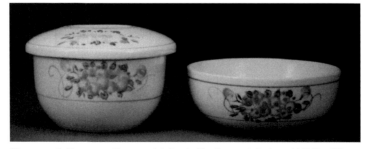

Dinnerware by Haengnam Co., porcelain bowl with a flowerpot design, mid-1940s, Private collection

As ceramic education caught on from the late 1960s, creative ceramics based on traditional porcelain was attempted by highly educated ceramic artists some of whom studied overseas. They wanted to go beyond the traditional practice of porcelain production and incorporate western art trends, which resulted in creative products. In addition, they produced a new generation of ceramic artists at major universities such as Seoul National University, Hongik University, Ewha Womans University, and Kyung Hee University; thereby leading the field of Korean ceramic ware during the 1970s and 1980s.

A rapid increase in the number of Japanese tourists following the normalization of diplomatic ties between Korea and Japan in 1965 encouraged the production of replicas of traditional ceramics, which in turn facilitated the revival of handed-down ceramics such as porcelain in Gyeonggi-do and Gyeongsang-do areas. Thanks to the introduction of gas-fueled kilns and electric potter's wheels in the 1980s several hundred ceramic kilns of various scales sprang up throughout Korea.

The Korean government awarded the title of Major Intangible Cultural Heritage (Master of Ceramics) to Kim Jeongok who was a seventh generation owner of a ceramic business in Gwaneum-ri, Mungyeong in 1996.

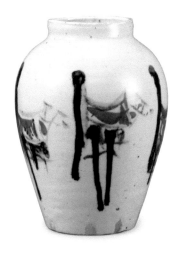

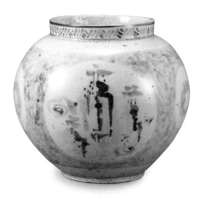

Jar with an Iron-brown Design, Chung Gyu, 1950s, Porcelain, h. 21.2cm, Gyeonggi Ceramic Museum

Jar with a Cobalt-blue Design, Yu Gangyeol, 1950s, Porcelain, h. 22cm, Gyeonggi Ceramic Museum

Regional Intangible Cultural Heritage (Master of Ceramics) was awarded to Kim Yuntae of Busan, Seo Donggyu of Danyang, Baek Yeonggyu of Goryeong, and Seo Kwangsu of Icheon in the same year. Those designated as the Masters ceramists (porcelain) — Kim Jeongok and Cheon Hanbong of Mungyeong, Seo Dongyu of Danyang, Seo Kwangsu, and Lim Hangtaek of Icheon; and Han Wansu of Sacheon — contributed to the continuance of the tradition and technique of Joseon porcelain to this day.

It may appear that Joseon porcelain would be unable to compete with modern ceramics which has undergone a series of modification processes. However, the more advanced a society, the more valued is tradition and the endeavor to know the past in order to understand the present. Porcelain is no longer considered a product of pre-industrialization. It embodies in a highly concentrated form the Korean people's Confucian concepts and aesthetics. In essence, porcelain reveals the confidence Koreans have had about expressing their ideals based on a perfect understanding of the nature of things. Unlike celadon or *buncheong* ware, porcelain displays its naked beauty. One could say that the success of porcelain is based on its powerful yet soft texture attributable to highly refined raw materials coupled with disciplined lines and color choices as the basis of design and art.

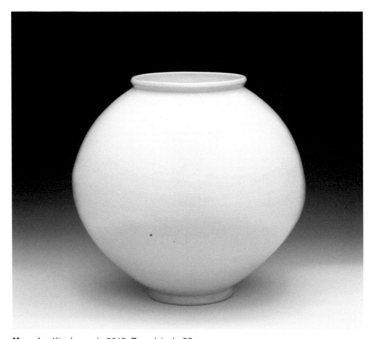

Moon Jar, Kim Jeongok, 2012, Porcelain, h. 60cm

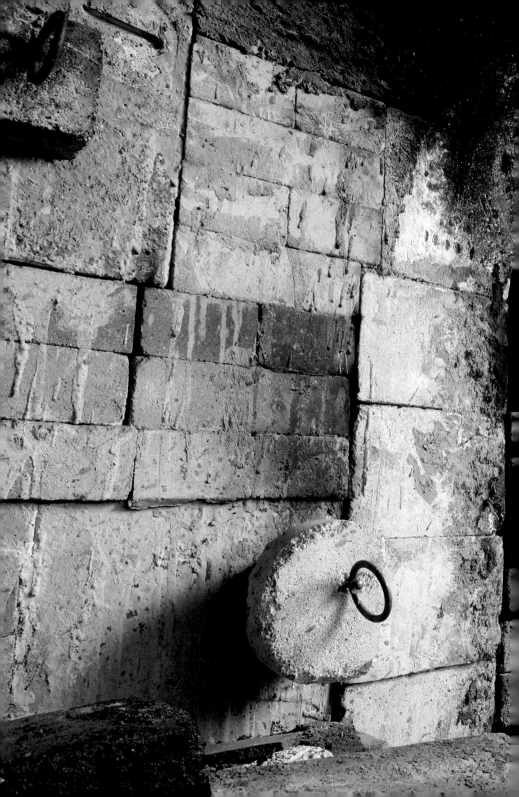

Chapter 2.
Materials and
Tools for Making
Porcelain

Clay, Material of Porcelain

Similar to other minerals on the earth's crust the raw material of porcelain mainly consists of silicon and aluminum. The main rocks (minerals) that constitute porcelain are silica (SiO_2), feldspar (a compound of Al_2O_3, CaO, K2O, Fe_2O_3, and MnO), and kaolin (a compound of SiO_2, Al_2O_3, and H_2O).

Kaolin, the major constituent of porcelain, creates high viscosity (plasticity) as it receives moisture in place of Na, K, Ca, Fe, etc. However, if kaolin is used alone, it becomes too vitreous and the porcelain may distort during firing. Therefore, it needs to be mixed with an adequate amount of silica and feldspar to prevent distortion and also to lower the melting point.

Representative Porcelain Clay

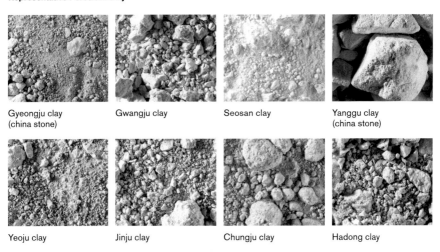

Gyeongju clay
(china stone)

Gwangju clay

Seosan clay

Yanggu clay
(china stone)

Yeoju clay

Jinju clay

Chungju clay

Hadong clay

Cross Section of the Clay Used for the Joseon Porcelain

Doma-ri,
Gwangju
(15th century)

Cheongdo-ri,
Gimje
(16th century)

Baengnyeon-ri,
Hadong
(16th century)

Seondong-ri,
Gwangju
(17th century)

Geumsa-ri,
Gwangju
(18th century)

The raw materials used for Joseon Porcelain have been recorded as "white clay", which indicates that the material was a compound of such minerals as kaolin, silicon, and feldspar in an adequate ratio. Yet it is also inferred that the raw materials were artificially concocted at times. Unlike the other raw materials for porcelain white clay needs to display white after firing. This necessitates white clay containing a minimal amount of iron, titanium, manganese which stain ceramic ware. However, it was not always easy to find high quality white clay meeting these conditions.

The royal kiln did not suffer the aforementioned problem because its white clay was from established origins which naturally had a more or less ideal combination of the necessary minerals. However, regional kilns had to deal with such issues as a deficiency of silica and an excess of calcium or titanium.

The Ratio in weight among the Chemical Properties of the Joseon Porcelain from Different Kilns

classification	SiO_2	Al_2O_3	Fe_2O_3	MgO	CaO	Na_2O	K_2O	TiO_2	P_2O_5	MnO
Geonup-ri No. 2, Gwangju (15th century)	71.53~ 73.85	18.20~ 20.21	1.56~ 1.90	0.46~ 0.64	0.10~ 0.35	0.15~ 0.43	4.34~ 4.79	0.12~ 0.17	0.02~ 0.04	0.01~ 0.02
Bangsan-myeon area, Yanggu (15th century)	73.83~ 77.50	15.64~ 18.69	0.56~ 1.00	0.33~ 0.80	0.13~ 0.64	0.12~ 0.66	4.16~ 5.17	0.02~ 0.07	0.02~ 0.07	0.09~ 0.14
Beoncheon-ri, No. 9, Gwangju (16th century)	67.71~ 75.06	17.42~ 23.90	0.86~ 2.30	0.28~ 0.58	0.12~ 0.37	0.47~ 1.60	4.19~ 5.02	0.08~ 0.20	0.01~ 0.05	0.02~ 0.05
Songjeong-dong, No. 5, Gwangju (17th century)	72.14~ 75.51	18.37~ 21.46	1.23~ 1.88	0.38~ 0.58	0.14~ 0.31	0.11~ 0.35	3.20~ 4.62	0.11~ 0.18	0.01~ 0.03	0.02~ 0.03
Daebak-ri, Cheongyang (18th century)	58.44~ 60.50	30.07~ 32.66	1.72~ 2.31	0.63~ 0.81	0.16~ 0.31	0.68~ 1.53	4.22~ 5.35	0.23~ 0.29	0.05~ 0.07	0.02~ 0.05
Bunwon-ri, Gwangju (late 18th-19th century)	70.26~ 77.03	17.25~ 22.26	0.78~ 1.84	0.32~ 0.53	0.13~ 0.70	0.38~ 1.55	3.17~ 5.28	0.02~ 0.15	0.01~ 0.03	0.03~ 0.07
Bangsan-myeon area, Yanggu (19th century)	73.58~ 76.07	16.64~ 18.79	0.47~ 0.68	0.31~ 0.56	0.13~ 0.73	0.15~ 2.36	3.93~ 5.08	0.01~ 0.03	0.02~ 0.04	0.10~ 0.12
Piseo-ri, Muan (19th -early 20th century)	61.64~ 65.17	28.79~ 32.93	1.03~ 1.26	0.14~ 0.22	0.00~ 0.18	0.12~ 0.19	3.22~ 4.59	0.09~ 0.14	0.01~ 0.02	0.03~ 0.05

Glaze of Porcelain

The glaze for porcelain is similar to clay in its constituent, but it differs from clay in that it completely melts during firing. That is, when clay is still semi-molten, glaze is completely molten turning to liquid, which results in the formation of a vitreous layer.

The glaze used for Joseon porcelain is made by adding water to the earth with a high content of silica. The resulting viscous liquid is applied to the clay body. To lower the melting point of the glaze some fluxing agent is needed. For Joseon porcelain 10-15% of calcium oxide was used as a fluxing agent; a thicker agent was used for making Goryeo celadon and *buncheong*

Materials of Glaze

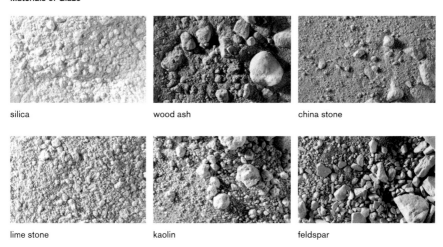

silica

wood ash

china stone

lime stone

kaolin

feldspar

The Glazed Surface of the Joseon Porcelain

Doma-ri,
Gwangju
(15th century)

Cheongdo-ri,
Gimje
(16th century)

Baengnyeong-ri,
Hadong
(16th century)

Seondong-ri,
Gwangju
(17th century)

Geumsa-ri,
Gwangju
(18th century)

ware. The calcium oxide agent seems to have been made by mixing wood ash or lime with glaze. That is, the glaze itself was a further development of a traditional lime type glaze.

In addition phosphoric acid (P_2O_5) and a high content of silicon oxide (SiO_2) and aluminum oxide (Al_2O_3), wood ash contains calcium oxide (CaO), sodium oxide (Na_2O), and potassium oxide (K_2O), the properties that help reduce the melting point and fuse the glaze; iron oxide (Fe_2O_3), manganese oxide (MnO), titanium oxide (TiO_2) that help adhesion of glaze. The phosphoric acid (P_2O_5) used for the Joseon porcelain glaze distinguishes Joseon porcelain from the modern version in that while phosphoric acid was mostly extracted from plants, feldspar and lime are mainly used in glaze for modern porcelain.

As Joseon porcelain progresses over time, the glaze contains a lower content of calcium oxide and iron oxide (used as a coloring agent). Compared to the royal kiln, regional kilns still used a large amount of coloring agent.

Chemical Properties of the Glaze Used for the Joseon Porcelain Produced from Kilns

classification	SiO_2	Al_2O_3	Fe_2O_3	MgO	CaO	Na_2O	K_2O	TiO_2	P_2O_5	MnO
Geoneop-ri No. 2, Gwangju (15th century)	60.66~ 62.11	14.91~ 16.98	1.03~ 1.74	0.59~ 0.89	12.24~ 16.78	0.50~ 0.67	3.53~ 3.94	0.04~ 0.07	0.00~ 0.04	0.03~ 0.05
Bangsan-myeon area, Yanggu (15th century)	59.63~ 64.18	13.00~ 15.16	0.73~ 1.08	0.86~ 1.17	15.35~ 17.42	0.00~ 0.30	3.96~ 4.89	0.00~ 0.28	-	0.00~ 0.30
Beoncheon-ri, No. 9, Gwangju (16th century)	52.97~ 60.84	12.83~ 15.59	0.88~ 2.89	1.07~ 2.26	9.25~ 22.18	1.14~ 2.11	4.79~ 8.32	0.00~ 0.41	1.72~ 4.07	0.00~ 0.53
Songjeong-dong, No. 5, Gwangju (17th century)	61.07~ 67.15	15.46~ 17.54	1.00~ 1.66	0.41~ 1.01	8.23~ 14.31	0.09~ 0.51	2.53~ 4.13	0.18~ 0.55	1.11~ 2.29	0.16~ 0.45
Daebak-ri, Cheongyang (18th century)	64.23~ 68.17	14.90~ 18.96	1.10~ 2.20	0.66~ 1.54	5.39~ 11.19	0.91~ 1.72	4.34~ 6.36	0.11~ 0.20	0.05~ 0.17	0.05~ 0.14
Bunwon-ri, Gwangju (late 18th-19th century)	62.64~ 65.92	13.05~ 16.22	0.50~ 0.99	0.61~ 2.09	8.23~ 12.16	1.60~ 3.05	4.01~ 5.56	0.00~ 0.29	1.10~ 1.57	0.09~ 0.38
Bangsan-myeon area, Yanggu (19th century)	63.56~ 69.18	11.76~ 15.04	0.48~ 0.77	0.27~ 0.68	10.91~ 15.53	0.00~ 1.16	3.67~ 5.79	0.00~ 0.24	-	0.00~ 0.26
Piseo-ri, Muan (19th-early 20th century)	61.12~ 68.88	13.64~ 20.46	0.79~ 1.83	2.64~ 6.48	2.57~ 7.58	0.92~ 1.48	3.82~ 6.89	0.21~ 0.68	0.30~ 0.87	0.11~ 0.56

Pigments Used on Porcelain

Because the pigment used on porcelain (underglaze pigment in particular) must contain minerals that survive beyond 1200°C when the glaze melts and express its expected color, only a few types of material may be used as pigment. Traditionally, iron oxide (iron-brown pigment), copper oxide (copper-red pigment), and cobalt oxide (cobalt-blue pigment) have been used. Although each pigment may be used alone, typically it is diluted in white clay water to create a desirable concentration level.

Iron Oxide (Fe_2O_3)

Iron oxide includes black FeO, red Fe_2O_3, and reddish black Fe_3O_4. The expressed color usually ranges from reddish brown to yellowish brown. Iron oxide can also function as a fluxing agent within the clay in addition to being used as a color softener which tones down such bright colors as cobalt-blue and chrome green. While iron oxide glaze displays blue/green with reduction firing, as is witnessed in celadon, it displays brown with oxidation firing. Iron content in clay or other materials tends to be regarded as impurity. However, a small amount of iron mixed in clay makes the porcelain display brown. In short, iron, if a small amount is used properly in the process of glazing, can create intriguing colors. However, it should be noted that clay with any amount of iron will lead to a product of low translucence, which is due to the iron colorant that melts along with the glaze.

 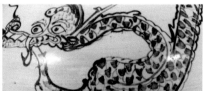

Iron oxide

Copper Oxide (CuO)

With feldspar, copper oxide displays turquoise when mixed with alkali fusing agent. Copper oxide and copper carbonate ($CuCO_3$) produce an almost identical effect, the only difference being that copper oxide produces a more solid color when an equal amount is used. Copper oxide should not be used for dining ware which is produced at a low temperature because copper oxide can result in potential toxicity. Even with vessels that are fired at a high temperature, the content of copper oxide should not exceed 2-3%. When more than 4-5% of copper oxide is used, it occupies the surface of the glaze creating a rough metallic tone instead of melting within the glaze. Copper carbonate creates pink with a dolomite type of glaze, red with reduction firing, green with lead glaze, and turquoise with alkali glaze.

 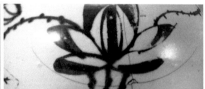

Copper oxide

Cobalt Oxide (Co_2O_3)

Cobalt oxide and cobalt carbonate produce an almost identical effect. Cobalt oxide produces a slightly more solid color and is thus more commonly used as a blue coloring agent. Cobalt oxide turns grey or even almost black when mixed with manganese, chromium, iron oxide, etc. while it turns pink or light purple when mixed with a small amount of manganese, or magnesium carbonate. Because cobalt is such a potent colorant, even a mere 1% of it can produce very strong blue. When an iron oxide and cobalt mixture with the ratio of 20:1 is added to glaze, the resulting blue is quite soft like the color of the Joseon porcelain with a cobalt-blue design.

Cobalt oxide

Facilities and Equipment of Workshop

A variety of facilities and equipment are required to produce porcelain. In addition to a kiln, a workshop needs to have enough space and the tools that allow it to process and store the raw materials, shape, trim, dry, and decorate vessels. For this reason it is not easy for a single individual to own a workshop. Consequently, to produce porcelain, traditionally master potters formed a community to collectively obtain various tools and practiced a division of labor according to different steps of a process.

Facilities for Processing Raw Material and Tools

Facility for Preserving Raw Materials

The clay materials are usually kept outside. To prevent the clay materials from being mixed with other types of earth and also the alteration of viscosity due to the increase in microorganisms, the moisture level and the temperature of clay should be kept consistent. In addition, a water-proof and insulating covering must be put over the clay when needed.

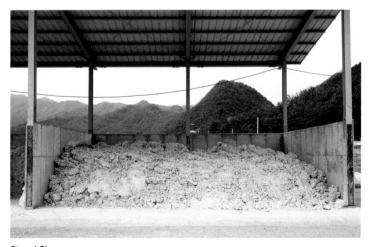

Stored Clay

Strainer

A strainer (*subijang, totmultong*) is typically made by digging a hole in the earth. Such kiln sites as Hugok-ri and Mungil-ri of Seungju, Jeollanam-do and the Suok-ri of Jangseong reveal a typical shape of strainer of Joseon dynasty. Strainers discovered in these sites were made with the following steps. A hole of a one-to-two-meter diameter was dug with a one-meter depth; then its circumference was pounded. Sometimes a flagstone was put down on the floor so that a person could go in.

Modern strainers still maintain most of the traditional features. Most often a large round hole of a three-meter diameter is dug with a two-meter depth with a flat floor, after which cement or tile is applied to prevent leakage. Then the earth is dug in a rectangular shape (1.5m×60cm) next to the strainer. A flagstone is laid on the bottom of the rectangular piet in a manner similar to the Korean heating system (floor heating system) and board walls are erected on both sides to serve as a *gwaeng* or *gwiung*, a place to store the clay.

Strainer

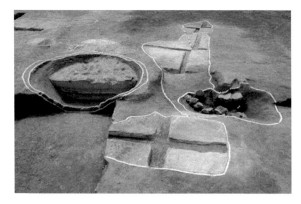

Strainer Site,
Deokheung-ri of
Yeonggwang

Ball Mill

The ball mill was not in use traditionally. It was introduced as a replacement for a strainer to finely grind porcelain materials. Its interior is filled with hard stones. After porcelain materials and water are poured into the mill followed by small round pebbles, it is rotated to produce fine grind. Often glaze materials are ground in a ball mill, although this process may cause the materials to have lower viscosity and absorb impurities from the stones.

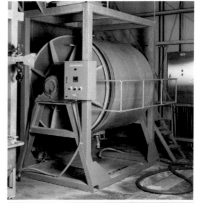

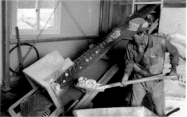

Ball Mill

Pug Mill

A pug mill is a machine that mixes clay into a proper state to be used. It uses a vacuum-pressure mixing system. The chamber through which clay passes has one or two shafts with numerous screw-shaped paddles. As clay is transported in one direction, it is mixed. When the clay is passed through a pug mill two to three times, it becomes homogeneous, air-free clay.

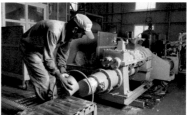

Pug Mill

Sieve

A sieve has a fine mesh that sifts slurry for the processes of straining materials or making glaze. Traditionally, fibroid material such as hemp was used for the mesh of a traditional sieve, but these days a wire mesh copper is used.

Sieve

The Structure of a Workshop

In Joseon dynasty a make-shift thatched hut was used for a workshop for porcelain. *Ondol*, Korean floor heating system, was installed in the most interior corner of the workshop for drying unfired vessels. Surrounding the heating floor was *tochijang* where strained clay was stored, a strainer, storage for white clay, a potter's wheel, etc. Below is a reconstruction of the royal kiln workshop of the late Joseon dynasty.

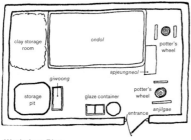

Workshop Plan

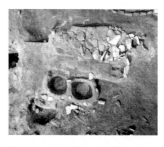

Workshop Site, Wolha-ri of Gangjin

- *Giwoong*: a container used for mixing the clay and water
- *Ondol*: a traditional Korean heating system where the floor is directly heated
- *Apjeungneol*: used for kneading the clay
- *Anjilgae*: a chair a potter sits when using a wheel

Interior

Potter's Wheels

Traditionally, a kick wheel turned by foot was used, but in modern times most workshops adopted a convenient electric wheel. The trunk of a kick wheel was made of solid wood such as daimyo oak and a mandrel made of birch was implanted into the ground. To reduce the friction between the trunk and a mandrel porcelain *gatmo* and *botgeuk* were inserted between the component parts, which were replaced by a bearing in electric wheels.

An electric wheel has a rotating plate (wheel head) powered by a motor, a belt, transmission, etc. The power and direction of rotation are controlled by a switch and the speed of the rotation is controlled by the pressure imposed by the foot.

Kick Wheel

A wheel for throwing high-fire ware is put on the work table, but the one for throwing low-fire ware is either directly placed on the ground or placed in a hole dug deep enough for the top of the wheel to be on an even level with the surface of the ground. When using a wheel in the ground, the potter sits on a board placed on the floor. However, when using a wheel on a table, a high and narrow potter's stool (*anjilgae*) is placed at each end of the table.

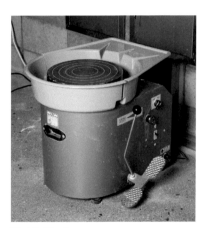

Electric Wheel

Boards

Boards are used to both dry and transport the shaped vessels. They are made of pine or plywood. Depending on the condition of the drying room and other facilities various sizes of boards (e.g., 60×60cm, 180×12cm) are used.

Boards

Bongro or **Heated Floor**

Bongro, a drying table or floor, is an important part of a drying room. It is also called *bungro*, *bongdang*, and *ondolbang*. *Bongro* refers to the floor on which the shaped vessels are dried enough for their next step, trimming their feet. In the workshops of Joseon dynasty a floor similar to an *ondol* floor was discovered next to the potter's wheels. A cement heated floor was used in many workshops until it was replaced by an electric-powered heated floor in recent times.

Heated Floor, electric-powered

Guptong or **Chucks**

Guptong or a chuck is used when the potter trims the foot to give a finished shape to vessels. Depending on the kinds of vessel, a variety of shapes were used. Often the chuck was made around the time vessels were shaped, which ensured a similar level of dryness between the vessels and the chuck.

Chucks

Gaejilbak or Ribs

Gaejilbak, also called *jijilbak*, is a shaping tool used to make the floor of the interior of a vessel even or push out the body of a form while shaping a vessel on a wheel. It is usually made of pine tree or a gourd dipper. It has a handle on one side to fit the right hand and a smooth round structure on the opposite end to be pressed against the inside of the vessel.

Gaejilbak

Gombangdae or Throwing Sticks

Gombangdae which looks like a smoking pipe is a tool for shaping a vessel. It is used when shaping a vessel difficult to reach with a hand such as a long neck bottle. Understandably, it replaces the potter's "inner" hand [i.e., the hand within the vessel as opposed to the one on the outside].

Gombangdae

Jeonggeumdae or Potter's Calipers

Jeonggeumdae, also called *jaemdae*, are made by carving a bamboo stem into a hinged cross shape for calibration. It is used to measure the depth of a vessel and the width of the mouth and is useful in duplicating a vessel of a certain size and shape.

Jeonggeumdae, This shape of *jeonggeumdae* or a caliper is used for a shallow vessel.

Being Used *Jeonggeumdae* to Measure a Vessel

Jeonggeumdae, another type

Jjaeljul or Cutting Wires

Jjaeljul, also called *samjul* and *seonro*, is made of a wire, a thread, or a fishing line. It has a handle on one or both ends. It is a tool used to cut kneaded clay or the bottom end of a vessel after the vessel has been shaped on the wheel.

Jjaeljul

Clay Knives

Clay knives are divided into angular knives (e.g., *garisae, gupsoe*) which are used to trim the foot of a vessel and trim the clay surface and carving knives (e.g., *yesae, beolsoe*) used to cut off an unnecessary part or engrave a design (in the latter case the knives have different shapes).

Clay knives are usually made of wood or metal. Potters tend to grind the knives to personalize the size and shape.

Carving Knives, relatively straight and smooth, are used to trim the foot or mouth and engrave a design on the surface.

Angular Knives, bent at its tip, is used to trim the foot and smooth out the surface by scraping.

Kiln and Firing Equipment

A kiln is by far the most important piece of equipment in a workshop. Most of the workshops that produce ceramic ware in a traditional manner used to have an outdoor climbing kiln which burn firewood. However, due to an unstable supply of firewood and low productivity most places have adopted gas kilns which have higher productivity.

Climbing Kiln

Climbing kilns have several chambers. A series of dome-shaped structures are connected through a firebox on an inclined plane. Each chamber has a separating flue which makes each chamber potentially an independent firing space with its own entrance and firebox. Each chamber is wider than long and is approximately 1.5×2.4m. In general, four to six connected chambers, occasionally as many as ten, form a single climbing kiln.

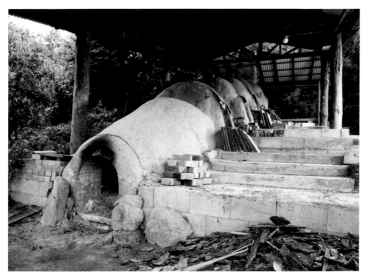

Climbing Kiln, with a Firebox, front view

Until now two methods of constructing a climbing kiln have been utilized. The first is the method in which the wall and the roof are connected by *mangsungyi*, a clay mass shaped in a wedge form. Here clay is used to fill in every space comprised of *mangsungyi*, and *boto* (scrap clay) is mixed with red clay, sand, and straw is and applied to the surface. The second method uses common refractory bricks as a convenient way to make a kiln of high durability. Even though refractory bricks are used, the surface of both interior and outside walls is completed by the application of *boto* such as clay, and *mangsungyi* is sometimes used for the ceiling which tends to have a bumpy surface.

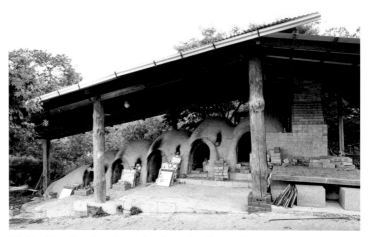

Climbing kiln, with a view of each chamber and a chimney, side view

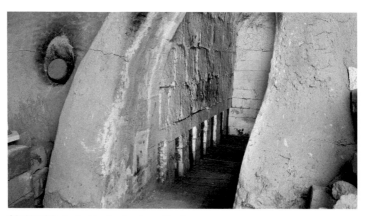

Climbing kiln, the inside of a chamber with a flue

The Development of Korean Kilns

A kiln is the most important tool in a workshop. What is characteristic about traditional Korean kilns is that most of them were climbing kilns and used wood as fuel.

In the Neolithic Age when clayware was first produced, the potters stacked firewood on the ground and put the terra-cotta in the middle of the stack and fired it, which is called pit kiln. Since this type of kiln could not generate a high firing temperature, a kiln that resolved this temperature issue must have come to the scene in the Bronze Age.

With the appearance of hard terra-cotta in early Iron Age and Proto-Three Kingdom period around the start of the common era, a kiln whose temperature could transcend 1000°C was manufactured. The early Iron Age kiln found in Sinchang-dong, Gwangju is an underground climbing kiln built in a ten-meter depth cave.

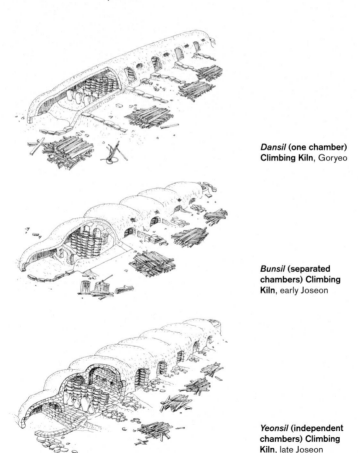

Dansil (one chamber) Climbing Kiln, Goryeo

Bunsil (separated chambers) Climbing Kiln, early Joseon

Yeonsil (independent chambers) Climbing Kiln, late Joseon

An underground cave style climbing kiln was further developed through the Three Kingdoms period and Unified Silla where oxidizing flame could be regulated to a certain extent unlike reducing flame (the flame produced without a sufficient amount of oxygen). The kilns of the Unified Silla period were advanced enough to produce ash-glazed ware, which was mainly produced in Jinjuk-ri, Boryeong, Chungcheongnam-do and Gurim-ri, Yeongam, Jeollanam-do.

The structure of the Korean kiln underwent a complete transformation with the production of celadon. As the glaze application technique and second firing became commonplace and the demand for ceramic ware increased, kilns were built on the ground on a larger scale and a side entrance was made which allowed vessels to be taken in and out easily and to kindle the so-called "side fire." A typical kiln of Goryeo dynasty is approximately 20 meters long with an inner width of approximately 120cm and is installed on a 15-25° incline on the ground. Most of the time the ground was dug to a shallow depth and the surface was smoothed out, upon which walls and a roof were built. The firing chamber is one long room stretching from firebox to the chimney. Most of the kilns in the Goryeo dynasty were made of clay and this tradition continued until early Joseon dynasty when porcelain began to be produced. A few exceptions were those kilns built to produce early Goryeo celadon and porcelain; they adopted the Chinese style of using red bricks to build kilns.

In the 16th-17th century Joseon, the structure of the kiln undergoes another transformation. Either a fire wall or baffle was built in a firing chamber to divide the chamber into several sections, which made a bumpy roof. This changed structure is witnessed in such sites as Yongsan-ri, Gochang and Jeongsaeng-dong, Daejeon. Although it is uncertain if this change was a nationwide one, certainly the royal kilns found in the Gwangju area in Gyeonggi-do exhibit partitions with baffles. Such kilns were widely used until the *yeonsil* kiln, a revised staircase style kiln, was introduced from Japan in late 19th and early 20th century.

Bunsil **Kiln**, Songjeong-dong kiln site in Gwangju, 17th century

Yeonsil **Kiln**, Bunwon-ri kiln site in Gwangju, 19th century

Mangsungyi **Kiln**, Wolsong-ri of Jangheung, 19th century

Gas Kilns

The gas kiln is now the most popular type of kiln and uses LPG (liquid petroleum gas) as fuel. It has a box style interior. It has a wall structure made of refractory bricks and this particular kiln has a pull-out door on the front. Each side of this kiln has five burners which can be adjusted. Depending on the size of the interior housing a kiln can be built in various sizes from 0.3 to 2.0m³ (cubic meters) with the most common one being 0.5 to 1m³. A gas kiln has a number of advantages including a relatively low fuel cost, ease in adjusting the temperature of the fire, and no flying ash. The advantage of its downdraft structure where the air first moves upward along the wall and travels back downwards before it exits through the chimney is particularly noteworthy; this distinct structure ensures that the vessels are evenly fired.

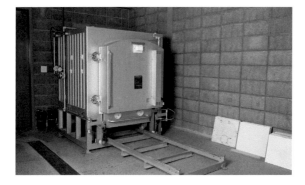

Gas Kiln

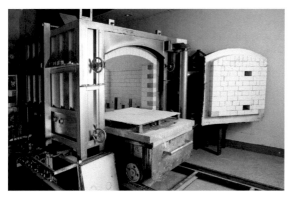

Gas Kiln, with
its door open

Electric Kiln

An electric kiln is operated by electricity and its advantages include ease of operating and a small required space. However, it also has some disadvantages. Because it uses fuel that does not burn, it cannot achieve reduction firing which allows a variety of changes in the glaze. In addition, the unit cost of the vessels is high due to its expensive fuel. For these reason electric kilns are less widely used than gas kilns. They are often preferred by small scale workshops or as a test kiln in a large workshop.

Electric Kiln

Electric Kiln,
with its door
open

Firing Pads

A firing pad is a refractory slab placed on the bottom of a kiln and ceramic ware is fired on it. It keeps the ceramic ware from sticking to the bottom of the kiln. These days instead of firing pads refractory shelves and posts made of fire clay are used to stack the vessels in kilns.

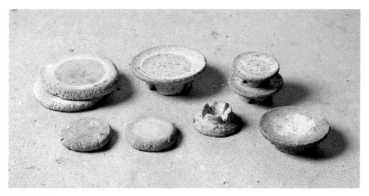

Firing Pads

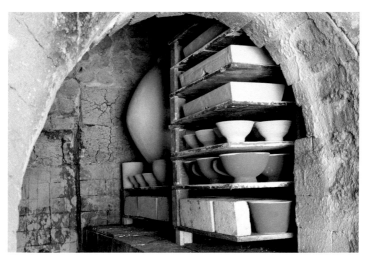

Vessels Stacked on the Refractory Shelves and Posts

Saggars

A saggar refers to a container used to encase ceramic ware when using the climbing kiln. It is called *gapbal* or *gaebi, naehwagab* in Korean. A saggar prevents the vessels from being discolored by wood ash. It ensures a fine quality of ceramic ware by blocking off flames and radiant heat. In addition, it circulates the interior heat evenly and maintains a high temperature for an extensive period of time. Modern gas kilns do not need saggars.

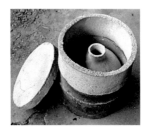

Saggars, Excavated from Dotong-ri, Jinan

Saggars, modern type

Cones and Test Rings

Approximately 7cm cones are made out of refractory materials (clay and glaze) to measure the temperature of the kiln. One face of a commercial cone has a number which refers to the melting point of the cone. When the tip of the cone melts and bends to touch the mounting pad, it signifies an appropriate temperature. Traditionally, a test ring of the same material as that of the vessel was used.

Cone

Cone
It can be made with the glaze used for the vessel.

Test Ring

Chapter 3.
Making Porcelain

Process of Making Porcelain

Preparing Raw Materials

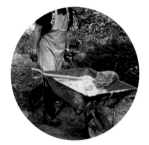 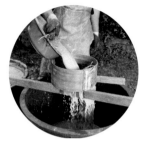 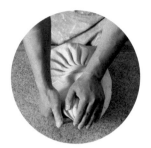

1. collecting raw materials	2. straining	3. kneading
The quality of porcelain is determined by the type of white clay used.	The collected earth is mixed with water to remove impurities from it.	The clay is kneaded to evenly distribute the moisture and remove fine air bubbles.

Shaping the Clay

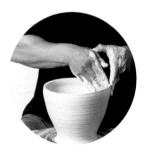 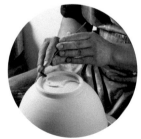

4. shaping (forming a shape)	5. finishing (trimming the foot)
An intended shape is formed using a wheel, a mold, or other various methods.	When a vessel is leather hard, its foot is trimmed and its surface is made smooth.

Decorating

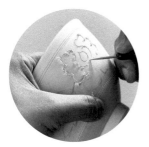

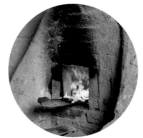

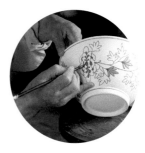

6. decorating

Before a vessel is dry, a decorative pattern may be rendered with intaglio, raised carving, openwork, or inlaying technique.

7. bisque firing

A completely dry vessel is fired at around 800°C to make the vessel adequate for painting and glazing.

8. decoration by painting

On the vessel that is bisque fired a design is painted using cobalt-blue, iron-brown, or copper-red pigment.

Firing and Completion

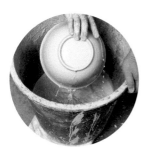

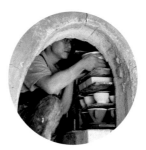

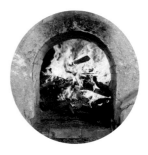

9. glazing

A bisque fired or dry vessel is dipped in or sprayed with glaze onto the surface evenly.

10. stacking

Vessels are stacked in the kiln in such a way that a maximum number of vessels are exposed to the heat evenly.

11. second firing

Vessels are fired at a temperature higher than 1200°C until the molten glaze can coat the surface evenly.

Preparing Raw Materials

The most fundamental step in making porcelain is the preparation of the raw materials of clay and glaze. The clay should have an adequate level of viscosity, refractoriness, and colorant. In addition, the process of homogenizing the particles of the clay and increasing its density is crucial to creating the ideal physical and chemical properties of porcelain.

Collecting Raw Materials

Porcelain is typically made of 1st clay which is high in silicon and alumina and low in impurities. Because very pure clay is often part of a mineral vein in mountainous regions, procuring it is not always easy. In addition, 1st clay needs to be fired at 1200°C or higher to be mature, and compared with 2nd clay it has low plasticity, which makes shaping difficult.

White clay with the aforementioned qualities is commonly found throughout the Korean peninsula. Korean kaolin is particularly famous for its fine quality due to its readiness for vitrification and strength. Since minute differences in raw materials are directly related to the fundamental factors that determine the quality of ceramic ware, in reality an extensive experience and labor force are required for procuring adequate clay.

Straining

The gathered earth must undergo the process of removing foreign elements such as coarse sand particles, organic material, and iron to be used for clean ceramic ware. Consequently, the gathered earth is finely ground, poured and stirred into a large pool of water, and sifted. Then the resulting fine sediment is collected for use. This multi-step process is called straining.

When sifting is done, a body of surface water is ladled out from the pool to reveal the sediment underneath. In the next step, the so-called "sun dry" (*yang-geon*) stage, the sediment is scooped out and dried to an appropriate degree. Traditionally, the sediment was evenly spread on a wide piece of cotton cloth or a straw mat in a wet field called bongdang and dried. In recent times the traditional sun drying method has been replaced by machines such as electric pumps and hydraulic compressors. Small size workshops that are equipped with a strainer either strain the clay using a large jar or use already strained clay.

Straining demonstrated by Park Sungwook

❶ Fill the tub with water to the brim. Pour the gathered earth in the tub and stir it.

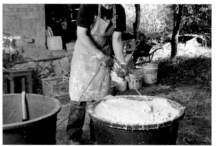

❷ Strain the slurry through a sieve to remove impurities such as sand. When the strained surface water is separated from the sediment, mix the surface water again with slurry and strain it. Repeat this step about three times. To speed up the separation of surface water and sediment, add a small amount of salt.

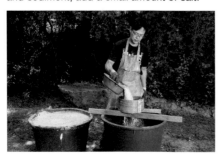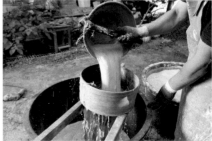

Yeonto or Kneading

Stored earth undergoes a kneading process before it is shaped into a vessel. This process is called *yeonto* or kneading where the clay is spread on the floor and kneaded evenly by foot to remove fine air bubbles in the earth, which prevents the vessel from cracking in the subsequent firing process. While adjusting the moisture of the wet clay to an adequate level, care should be taken not to introduce any impurities. The last stage of the kneading process is spiral wedging which enables the clay to have a highly homogenized texture by ensuring the clay is free of air bubbles and has evenly distributed moisture. Most workshops these days either use a pug mill to replace manual kneading or use already kneaded clay in which case only spiral wedging is required.

Spiral Wedging demonstrated by Park Sungwook

Prepare a kneadable size clay mass on the table. Using fingers and palms, press the clay turning it in a spiral form. That is, press the clay from center outward and press the pushed clay inward. Repeat this process. Once spiral wedging is done, shape the clay into a cylinder form and cover it with a plastic wrap so that it stays moist.

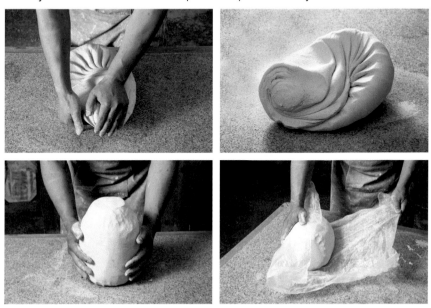

Shaping the Clay

Throwing on the Potter's Wheel

Kneaded clay is placed on the wheel in a lump to be shaped. A potter's wheel consists of a rotating wheel head and a mechanism that spins the wheel head to create a shape of a vessel. In the past a kick wheel (wooden wheel) turned by the foot was widely used, which surrendered its place to an electric wheel in recent times.

Different types of potter's wheel are used in different manners depending on the intended type of vessel. When making low-fire vessels, usually a large and heavy wheel with a diameter of up to 60cm is turned slowly using coiling method or ring method. However, when making high-fire vessels, only a single mass of clay is placed on a small, light wheel, which then is turned fast to produce a small vessel.

Names of Detailed Parts of a Bowl

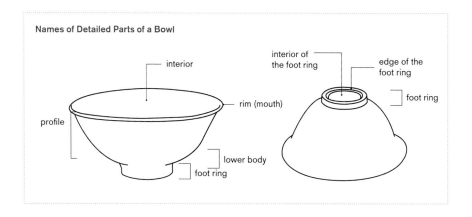

interior

interior of the foot ring

edge of the foot ring

rim (mouth)

foot ring

profile

lower body

foot ring

❶ Put the prepared clay on the wheel. Next, wet both hands and slowly turn the wheel clockwise and compress the clay utilizing a firm hand.

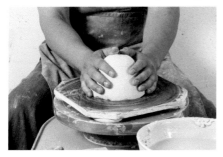

❷ When shaping on a wheel, centering the clay is important. To center the clay pull it up as if squeezing it and press it down with the palms while the wheel is turning. Repeat this step several times.

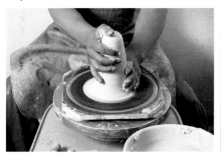 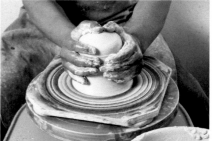

❸ Make a hole of appropriate size by pressing down the top of well-centered clay with both thumbs.

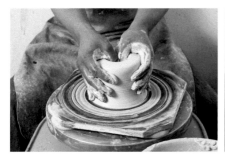 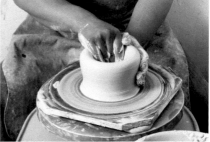

❹ First make a cylinder shape while applying moisture to the inside of the hole. Gradually, turn the shape to that of a bowl. While doing this, let the right hand and the left hand manage the inside and outside of the bowl, respectively.

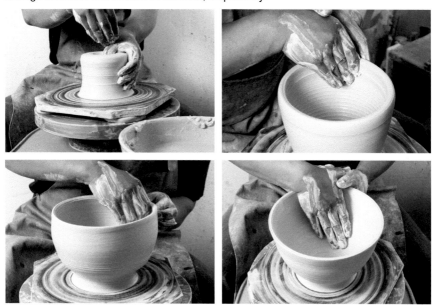

❺ Periodically, measure the depth of the bowl and the width of the rim, using potter's calipers.

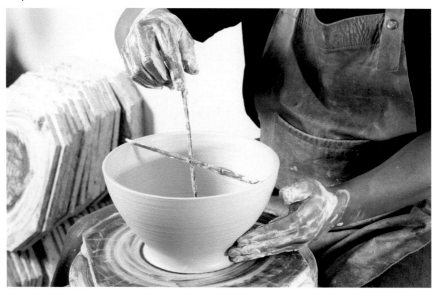

❻ Smooth out the inside of the bowl using a *gaejilbak* or a rib.

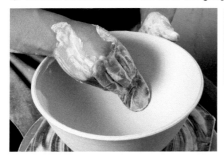

Tip

Smooth out the inside of a long-necked vessel such as a bottle, using a *gombangdae* (throwing stick).

❼ Smooth out the rim of a vessel using a strip of wet cloth.

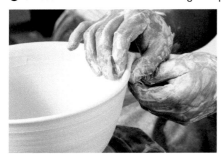

❽ When the shaping of a vessel is done, grab an end of a cutting wire in each hand and cut off the vessel by evenly running the wire between clay and wheel head. Place the separated vessel on a board. When the board is occupied with vessels, move the board to a shady place or a drying room.

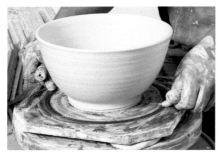 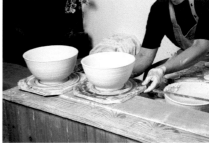

Other Shaping Methods

Porcelain may be shaped using other methods than a wheel. Two methods are commonly used. The first one is a hand-building method where one directly shapes a vessel using hands. The second one is a slab building method where slabs of clay are fitted together to create a form. These two methods allow one to shape various forms. Yet other methods include using a machine wheel for mass production of vessels and others using plaster molds.

Among machine techniques the jigger wheel and roller machine are widely used. In the jigger wheel method, a plaster mold for either the inside or surface of a vessel is placed on the rotating head of the wheel, on top of which is placed a clay slab. When the wheel is turning at a high speed, the potter places a knife shaped in the cross section of the opposite side of the vessel and shaves off clay to shape the vessel. In the roller machine method, a ball of clay is placed within a mold in the form vessel's outer wall and a roller presses, in the shape of the inside of a vessel, press it to the appropriate thickness. As the roller is turned, a form is created. Both these methods have the advantage of being able to mass produce vessels of identical shape fast, which explains why they are primarily used in factories producing everyday vessels of standard sizes.

When a mold is used to shape, press molding or slip casting is used for irregular or non-round vessels. Pressure casting which shapes clay by compressing the clay in the mold is often used for decorative articles or articles that have a wide flat surface to be molded. In making small decorative articles, the clay is pressed into a mold by hand. However, when making such articles as tiles, the material is put in a metal mold and a powerful compressor is used to press and create a form. In the slip casting method, clay slurry or slip is poured into a plaster mold. After some time elapses, the slip is poured out so that the mold may reveal the shape of the dry vessel. Clay slip is made by mixing the dry clay with 15-25% water. It develops a soup-like texture and its viscosity is adjusted by adding a deflocculant or a flocculant.

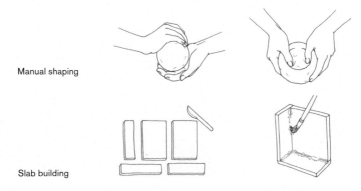

Manual shaping

Slab building

Finishing: Trimming the Foot

To finish the foot of a vessel, the vessel is placed upside down on a ready made chuck and while the wheel is turned counterclockwise, the inside and outside of the foot along with the surface of the vessel is finished with an angular knife.

This finishing process determines the shape of the foot and brings the vessel making closer to completion. For this reason this process is a most crucial step that distinguishes high quality vessels from low quality ones. Typically, with the fine vessels produced in the royal kiln the foot is trimmed clean vertically or with a tapered profile while the inside of the foot is smoothed out.

The finishing process of low quality wares produced from the royal kiln and those from regional kilns for private use were simplified to raise productivity. To be specific, it was merely trimming the foot with a foot that looks like the cross section of a bamboo stem or tall thrown foot and finishing the corner of the foot with a knife. The quality was even lower with regionally produced vessels because they used low density clay in the first place and the foot was often trimmed while the vessels were not completely dry, which resulted in rough corners of the foot, glaze that peeled off, and poor color reaction due to oxidation.

Trimming the Foot of Porcelain demonstrated by Park Sungwook

❶ Fix a hat shaped chuck on the center of the rotating wheel head using water or clay. Trim the chuck with an angular knife and place on it a vessel that has been dried for about a day upside down.

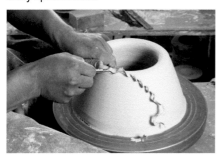 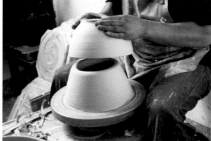

❷ Mark the width of the foot and start trimming to create the shape of the foot.

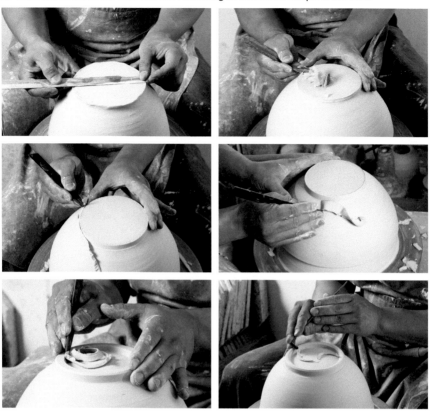

❸ Since trimming the foot is the last phase in the finishing process, give a smoothing treatment to the surface of the vessel to bring the vessel making process closer to completion. Trim the area around the foot as well as the whole surface area of the vessel to remove the hand marks left while shaping on the wheel.

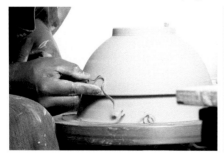
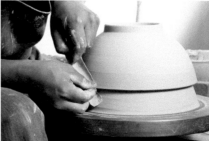

Shaping a Moon Jar

In general, the size and shape of a porcelain vessel is determined by the amount of wedged clay prepared and the size of the wheel. In other words, except for some special cases the size and weight of Joseon porcelain is determined by the amount of wedged clay that can be shaped on the wheel at a time. In addition, because the size of the wheel head is small, the diameter of the foot is seldom over 20cm.

To overcome the above restrictions a joining technique called the *eopdaji* method in which two bowls were fitted together to connect them was used for shaping large jars or "moon Jars" during the 17th-18th century of the Joseon dynasty. Because the moon jars shaped in the joining method are shaved at their rims with a knife, they have a rather linear shape.

Shaping a Moon Jar demonstrated by Park Sungwook

❶ Put the prepared clay on a bat on the wheel head. Then form a cylinder shape appropriate to the size of the intended size of the vessel. Gradually widen the cylinder from the rim until it takes on a bowl form.

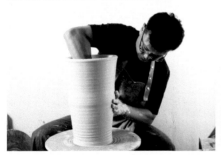
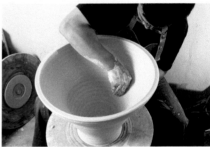

❷ Measure the width of the rim. Create an identical bowl using the same method. It is critical for the two bowls to have identical width. Cover the rims with a plastic wrap so they stay moist.

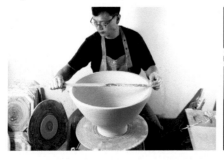

❸ After the two bowls are leather hard, score the rim area and apply slip to it.

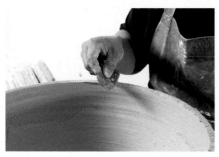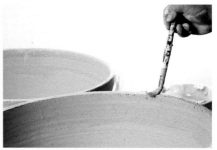

❹ Invert one bowl with the attached bat onto the other bowl. Using a cutting wire remove the bat on top.

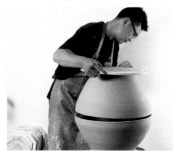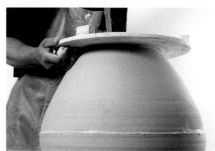

❺ Seal the connecting part using the hand or a wooden knife.

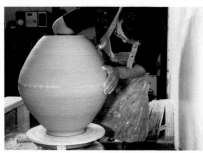

❻ Using a cutting wire make a hole appropriate for the mouth size of the jar.

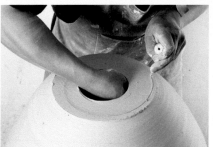 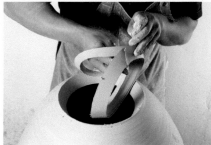

❼ Using an angular knife form the overall shape of the mouth rim. Then cover the rim with a plastic wrap and dry it.

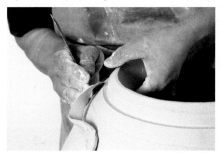 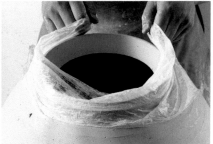

❽ Prepare a chuck appropriate for the size of the jar and trim it. Using water or clay fix the chuck in the center of the wheel head.

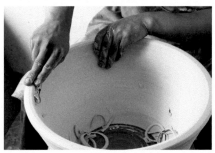 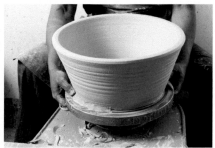

❾ Uncover the jar that has been dried for about a day. Place it upside down on top of the chuck. Trim the foot and the surface of the jar with an angular knife.

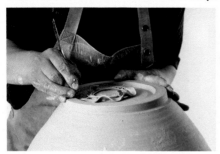 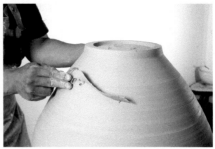

❿ Put the jar in an upright position to trim the mouth rim. Check the overall shape of the jar and trim and finish with a surface treatment.

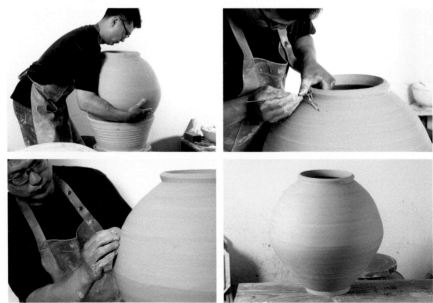

Decorating

Carving Decoration Method

In the painting method, designs are painted with a brush, and the decoration is done after bisque firing so that the clay stays stable and the pigment adhere well. However, with carving or inlaying method, usually decoration is done after shaping but before a vessel is completely dry.

In carving method decoration is not done by using pigments but by creating a three-dimensional surface variation by manually molding a design or engraving a design with a knife. Using molds raised or intaglio designs can be expressed in the mold beforehand, so separate design processes are not required. However, carving and openwork method may be partially introduced in the process to accommodate an intricate design that cannot be fully expressed in a mold. Depending on the way design is engraved, it is divided into intaglio, raised, stamped, and openwork techniques.

Sculpting method typically proceeds with the following steps. First, a base sketch is done on the surface of a vessel using a pencil or a stylus. Engraving is done starting with larger strokes. Large vessels such as a jar or a plum vase (*maebyeong*) are placed on a wheel and the design is engraved by turning the wheel. However, small vessels such as smaller bowls are placed on the lap with sponge as a buffer. Stamping method expresses a design by stamping a design on a vessel when it is still moist. When stamping with one hand, the other hand must support the interior of a vessel to avoid distorting the shape. When engraving is not completed in one sitting, water is sprayed on the vessel to keep it from drying and it is covered with plastic wrap before it is put away.

❶ Sketch a design on the surface of a vessel. Apply the pigmented slip premixed with water over the sketch. Using a container like a squeeze bottle is convenient.

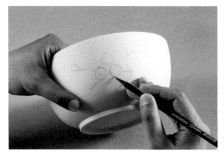 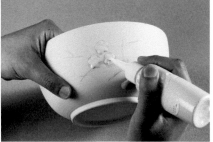

❷ When the applied slip is dry, gently scrape the edge of the design using an angular knife. If necessary, use a carving knife to define the borderline.

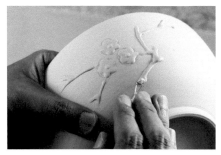 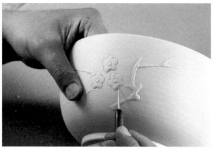

❸ Design with raised carving technique.

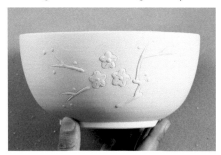

❶ Sketch a design on the vessel. Carve out the sketch with a carving knife.

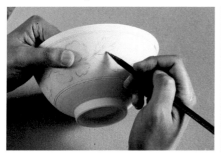 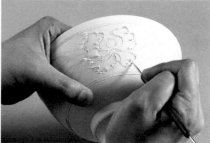

❷ Fill in the carved area with black clay. When the black clay is dry, trim with an angular knife.

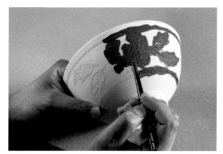 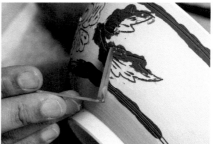

❸ Design with inlaying technique.

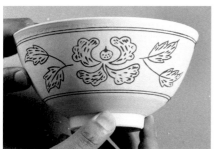

Bisque Firing

When a vessel is shaped, it is dried thoroughly in a shady place. Then it undergoes bisque firing. Bisque firing, also called first firing, refers to a process of firing which is done at a slow pace to 700-800°C. Glazed porcelain is usually fired twice. Without bisque firing vessels will not be hard enough, making the application of glaze difficult and the glaze will not adhere well to the surface.

Bisque firing is not affected by the interior atmosphere of the kiln such as oxidizing flame and reducing flame. Since the vessels for bisque firing are free of glaze at this point, they can be stacked against each other to be fired. Since bisque firing does not require a high temperature, often times it is done in the last chamber of a climbing kiln during a second firing without kindling the fire box. Toward the end of bisque firing the temperature is raised progressively faster, and when the temperature is high enough to burn off the soot on the chamber ceiling, the bisque firing is done. At that time the fire is extinguished and the peep holes into the kiln are completely sealed. The cooling process is also very important. If a kiln door is opened while the vessels are still hot, they can crack due to the large temperature difference between inside and outside of the kiln. For this reason vessels remain in the sealed kiln for one or two full days before being taken out.

Bisque Firing in a Climbing Kiln demonstrated by Park Sungwook

Stack the vessels inside the kiln and seal the kiln doors and peep holes with refractory bricks and clay except for a firing port. Firing is done exclusively through the firing port. When using more than one chamber of a climbing kiln, light the last chamber closest to the chimney first.

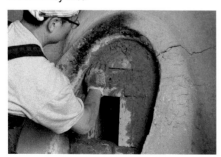
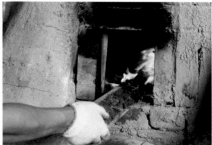

Making Designs: Painting Method

When painting a design on a vessel with a brush, mineral pigments that develop different colors are mixed with water before being used. To decorate porcelain cobalt-blue, iron-brown, and copper-red pigments are mainly used, which are comprised of cobalt oxide, iron oxide, and copper oxide, respectively. With Korean porcelain only underglaze painting technique is used; thus, the design is painted on the vessels prior to the application of glaze. While occasionally, as in the case of omitting the process of bisque firing, designs are painted by a brush on a dried shaped vessel, typically designs are painted after the vessels are bisque fired to keep clay from sticking to the brush.

Decorating with Cobalt-blue Pigment demonstrated by Han Ilsang

Sketch a design on a bisque fired vessel. Paint the design with a pigment of choice.

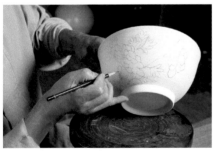
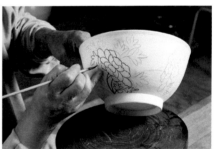
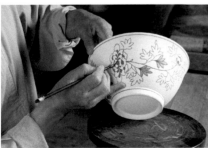
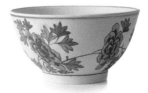

Firing and Completion

Glazing

Glazing refers to the process of applying glaze to the surface of a bisque fired vessel. Glazing techniques may be divided into the following types: dipping method where a vessel is dipped in the glaze, spraying method where glaze is sprayed on the vessel surface, brushing method where glaze is applied with a brush, and pouring where the glaze is poured over the vessel. In the traditional ceramic industry, dipping method was usually used.

Stacking

Stacking refers to the process of stacking vessels to be fired in a kiln. Special skill is required in stacking: the maximum number of vessels should be stacked in the kiln while ensuring even circulation of heat. With a modern kiln refractory shelves and posts are used to stack, which allows the potter to stack the vessels directly through the kiln door. With a large kiln a shuttle on which vessels have been stacked is pushed in to make stacking easy.

In a traditional kiln, the potter himself goes into the kiln and stacks the vessels that are handed to him through the open door. He also has to make sure that there are no cracks in the walls or ceiling before firing. In the meantime, an assistant stacks firewood next to the firebox. For the sake of efficiency larger vessels are stacked one by one on the floor with a shelf separating them while smaller vessels are stacked beside one another, using saggars or refractory shelves. Typically, refractory shelves or saggars are arranged to create a refractory wall and behind them are stacked larger vessels. Expensive vessels are placed in the inner corners of the kiln where they are not directly exposed to the fire. Once stacking has been done, the door is blocked with bricks and a firing port is made through which fire is stoked.

❶ Stir the glaze to mix it well. Dip the vessel into the glaze container. With smaller vessels such as small bowls, hold the body or foot and dip the vessel deep. With larger vessels such as jars, first apply the glaze on the inside of the jar; then dip it in the glaze container. Turn the jar while dipping it so that the glaze can be applied to every inch of the surface.

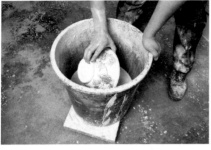 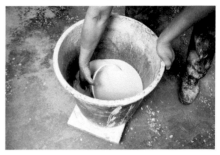

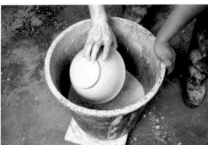

Tip

The longer a vessel is dipped, the thicker the glaze will be. Adjust the dipping time according to the preferred thickness.

❷ Wipe the glaze from the foot of the vessel and dry it. When the vessel is dry, trim it with a finishing knife.

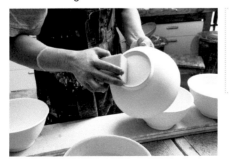

Tip

Glazed vessels are placed on a board to remove hand marks. At this time more glaze can be applied with brush or smoothed out if necessary.

❶ Stack vessels one by one using refractory shelves and posts.

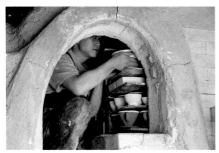

> **Tip**
>
> When stacking, if the melting point of the glaze is high, place the vessel in front and toward the bottom rather than in back and toward the top. When vessels are fired without the use of saggars, ash may adhere to vessels in front rows. Thus, clean vessels need to be placed in the rear.

❷ Put a cone along with test rings in view of a peep hole.

❸ Block and seal the door to each chamber with refractory bricks and mud. A fire opening through which the fire will be lit may be temporarily blocked with bricks until the actual firing to keep warmth in.

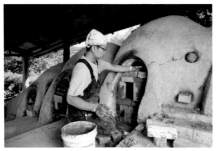 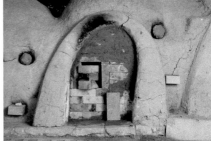

Second Firing

Second firing is done at a high temperature and brings the process of making porcelain to an end. In a conventional kiln second firing starts by setting fire in the firebox at the front of a kiln. The temperature is raised at a slow pace to 800°C as in bisque firing, after which the temperature is raised rapidly until it reaches over 1200°C. In this process the atmosphere of a kiln is changed to transform oxidizing flame into reducing flame, melting the glaze.

Along with firing temperature and kiln atmosphere, the duration of firing is an important determinant of the color of the glaze. In principle, the kiln temperature must be raised and cooled in a very steady manner to prevent the inner moisture and air from rapidly expanding and the glazed surface from crawling. However, this is not always easy to handle for potters when the kiln itself has intrinsic limitations or they have to consider such issues as fuel supply and productivity.

The duration of firing is directly related to the display of the pigment. If the firing is not done long enough, a lack of adhesion between clay and glaze occurs even if the glaze has melted. In contrast, if the firing is done rather too long, the liquidity of glaze increases; which helps the glaze adhere to the clay but in the process creates minute particles where clay is in contact with glaze, which results in clouded color of vessel.

Second Firing demonstrated by Park Sungwook

❶ Kindle fire to heat the entire kiln.

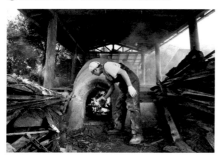
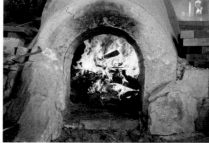

❷ When the fire has passed into the first chamber from the firebox, start the second chamber fire so that the fire can keep spreading upward. Pull out test rings to check the temperature and atmosphere of the first chamber and repeat the process through the last chamber. If you want to create a reducing atmosphere, continue to burn the wood fire until the flame comes out of the window of the next chamber. If you want to create an oxidizing atmosphere, wait until the fire comes out of the next chamber and disappears and then start burning wood fire.

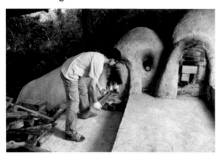

❸ Cool the kiln for at least a few days before opening the door. The interior of a kiln after cool down.

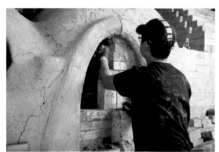
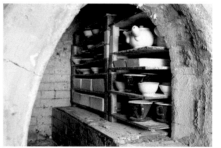

❹ First, clean out the ash pit and pull out the vessels. A completed porcelain bowl with a cobalt-blue peony design.

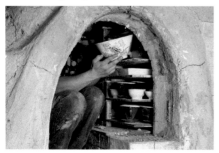
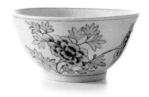

Chapter 4.
Enjoying
Korean Porcelain

Symbol of Dignity:
Jar with Dragon Design

The porcelain jar with a dragon design is a representative ceremonial vessel which was used at a small-scale banquet or an ancestral ritual of the royal family as a wine jar or a flower vase. Typically, it was tall and came with a cobalt-blue dragon design, wide shoulders, and a tapering mid-section. Joseon porcelain jars were very expensive because most of them used a pigment imported from China. Despite the requirement for an extensive labor force the Joseon royal family consistently demanded the production of porcelain jars with a dragon design and appreciated them. When cobalt-blue pigment was not accessible, they used jars with iron-brown pigment or a *buncheong* ware version of dragon design jars instead. There was a good reason why the Joseon royal family continuously showed a serious interest in producing porcelain jars with a dragon design. Those jars were not only representative royal family ware as ceremonial vessels but also were considered a symbol of the dignity of the Joseon dynasty itself.

Joseon porcelain jars with a dragon design are considered consummate among porcelain vessels. They have an imposing form. They usually stand close to 60cm, which is the upper limit to porcelain vessels of the period. They also have a lip which reveals discipline and a round vitreous body which narrows toward the foot.

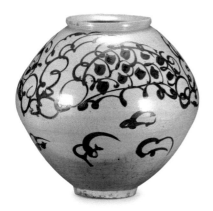

Jar with Decoration of Clouds and Dragon,
17th century, Joseon, Porcelain with underglaze iron-brown design, h. 36.1cm, National Museum of Korea
This porcelain jar in the shape of a round moon jar was made in late 17th century. The design expresses a magnificent and dynamic scene of a dragon passing through the clouds with the head and legs shrouded by the clouds. This kind of jar with an iron-brown cloud and dragon design is emblematic of the royal kiln porcelain jars with an iron-brown design that were circulated among aristocrats and commoners in the late Joseon dynasty.

Jar with Decoration of Clouds and Dragon, early 18th century, Joseon,
Porcelain with underglaze iron-brown design, h. 57.5cm, National Museum of Korea
This large jar was used as a ceremonial vessel. It displays a keen sense of volume. The design was painted
in an iron-brown underglaze. Traditionally, cobalt-blue pigment is used to paint the cloud and dragon design
on ceremonial jars. However, as procuring cobalt-blue pigment became difficult immediately after the two
invasions by the Chinese and the Japanese during the Joseon dynasty, iron-brown pigment was used as a
substitute. Usually, iron-brown pigment does not allow a stable color expression due to its coarse particles and
high liquidity. This jar is rather exceptional for its rich shades of color and an exquisite detailed expression of
fine lines.

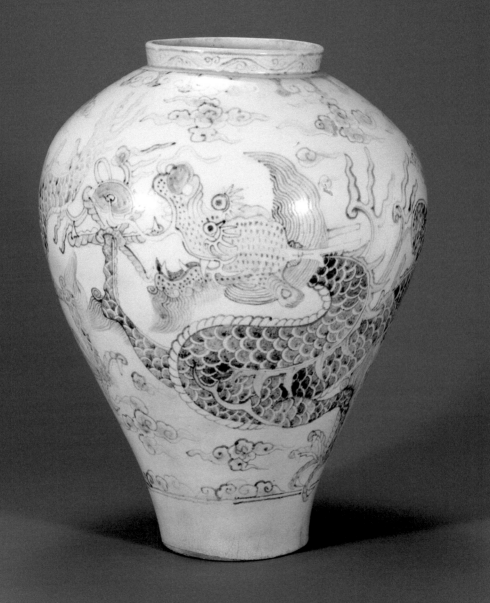

Jar with Decoration of Clouds and Dragon, late 18th-19th century, Joseon,
Porcelain with underglaze cobalt-blue design, h. 53.9cm, National Museum of Korea
This jar is decorated with a dragon with five-toed feet. It is called *baekja yongjun* in Korean,
meaning white porcelain vase with a dragon design. It was used as a wine jar or a flower
vase at royal ceremonies. It stands out among the Joseon porcelain jars with a dragon
design for its imposing height and intricate and elegant design.

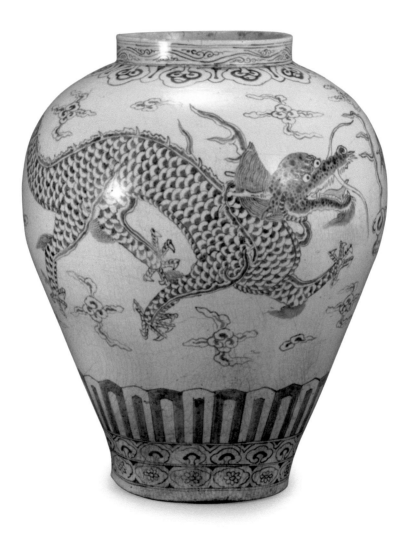

Jar with Decoration of Clouds and Dragon, late 18th century, Joseon,
Porcelain with underglaze cobalt-blue design, h. 38cm, Gyeonggi Ceramic Museum
This jar has balanced proportions, a full body, and a straight and long neck, which is
representative of ceremonial jars of the 18th century Joseon. The head of *ruyi* design is
encircles around the shoulder and lower body and the body is painted with a dynamic
scene of an animated dragon in the clouds as if he were about to swallow a pearl.

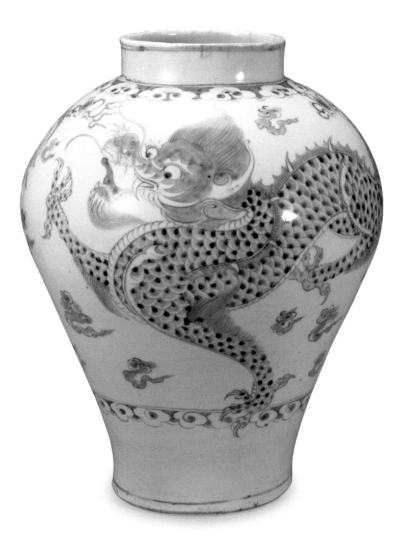

Embodiment of Nature: Moon Jar

Among the large porcelain jars of Joseon dynasty the ones that have the shape of a moon are called moon jars. The production of moon jars started in Saong-ri royal kiln in Gwangju of Gyeonggi-do in the mid-17th century. By the early 18th century Geumsa-ri royal kiln produced elegant large moon jars.

Moon jars strive for a perfect circle. They represent the essence of porcelain in that they express profound beauty in a simple shape and that they display maximum volume with a minimum amount of clay. They distinguish themselves as representative Korean porcelain from Chinese or Japanese porcelain with their impressive yet buoyant beauty. Moon jars are made using the *eopdaji* method where two large bowls are fitted together. Two vessels that are fitted together are joined to form a single body, which after withstanding the pressure and gravity in a hot kiln emerge as an object with physical balance. In short, the beauty of moon jars consists in the beauty that is perfected by the power of nature.

The Joseon moon jars are thought to have been used by the royal family and aristocrats as ceremonial vessels, for storing food, or just as objects of appreciation. Unfortunately, moon jars were forgotten for some time by Koreans. Then as the interest in both domestic and foreign antiques heightened from the turn of the 20th century, moon jars began to be in the spotlight once again as a representative cultural heritage that manifests the Korean people's ethnicity, identity, and aesthetics.

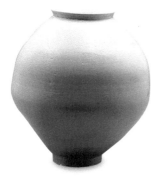

Moon Jar, 17th-18th century, Joseon, Porcelain, h. 49cm, Woohak Cultural Foundation, National Treasure no. 262
Moon jars are made by joining two bowls and are usually tilted slightly during firing. For this reason they have visible seams where the joining occurred and their overall shape is not a perfect circle. However, these characteristics contribute to their natural and free-spirited beauty. This jar is almost devoid of blue and displays cream color, which gives warmth. This jar is a perfect illustration of Joseon moon jars with its subtle white color, simple moon-shaped form; offering a sense of generous abundance.

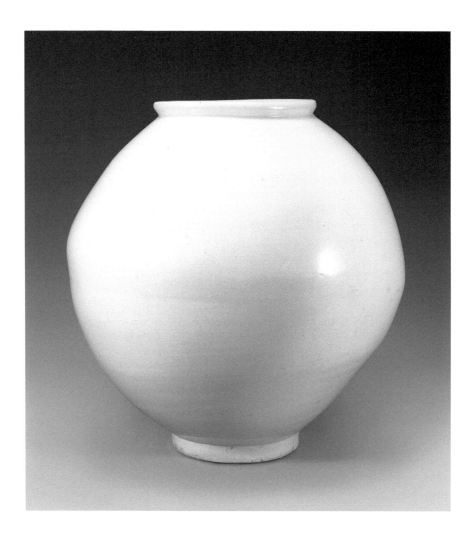

Moon Jar, early 18th century, Joseon, Porcelain, h. 43.8cm, private collection, National Treasure no. 310

This round jar appears rather large, but it still carries an overall balance with an ideal ratio between the rim diameter and the base diameter. An adequate height of lip and foot keeps the jar from appearing heavy or sluggish with a flaccid body. It has a slightly twisted or altered shape rather than a perfect symmetry; yet this irregularity adds dynamism and naturalness to its stature.

Aesthetics of Life:
Porcelain Bowl

The shape of a porcelain bowl may be compared to a poem. The aesthetic sensibility of a given period is compressed in the simple and abbreviated profile of the porcelain bowl.

Bowls are divided into *jubal, balwu, bari, baltanggi, bosiki,* and *wan* depending on their usage. They were used to contain various kinds of food such as rice, *kimchi,* soup, and tea. However, it is not easy to classify them by shape. Nor was it the case that they were produced strictly according to their distinct uses. Thus, it may be concluded that *sabal* is a generic term that refers to a large and open container which can be used for various purposes.

The royal kiln of Joseon dynasty usually produced high-quality bowls that have tall feet and are voluptuous, white, and sleek. In provincial areas a large number of low quality porcelain bowls named *maksabal* (all-purpose *sabal*) were produced as affordable multi-purpose vessels for the commoners. Some of them were taken to Japan during the Japanese invasion of Joseon; they were praised as the best tea bowls by the Japanese.

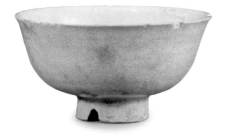

Bowl, 16th century, Joseon, Porcelain, h. 7.2cm, Gyeonggi Ceramic Museum
This is soft-paste porcelain built with the technique of the Goryeo dynasty. Soft-paste porcelain of early Joseon was mainly produced in Gyeongsang-do such as Goryeong, Sancheong, and Jinju. Its light weight and excellent heat retention make it ideal for a tea cup. This small bowl has a rather high foot with a small fragment missing and a wide body. Its neat shape expresses dignity.

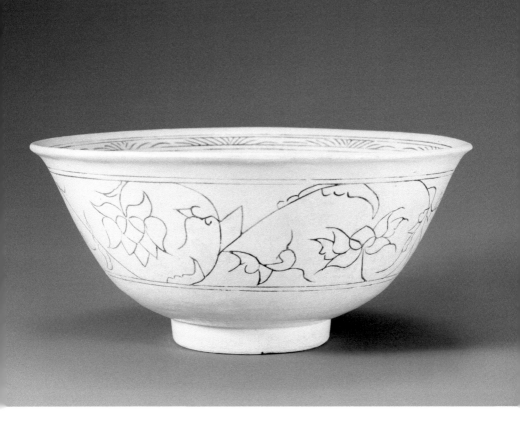

Bowl with Decoration of Lotus Vine, 15th-16th century,
Joseon, Porcelain with inlaid design, h. 7.6cm,
National Museum of Korea, National Treasure no. 175
The inlaid porcelain of Joseon inherited the tradition of Goryeo
celadon which often has an unrefined inlay. Yet this bowl displays
a succinct finishing touch, a soft texture, and an elegant design.
The simple vine design decoration that matches the simple form
of the vessel is reminiscent of the blue-and-white of the late Yuan
and early Ming of China. The brush strokes on the design are both
sharp and soft.

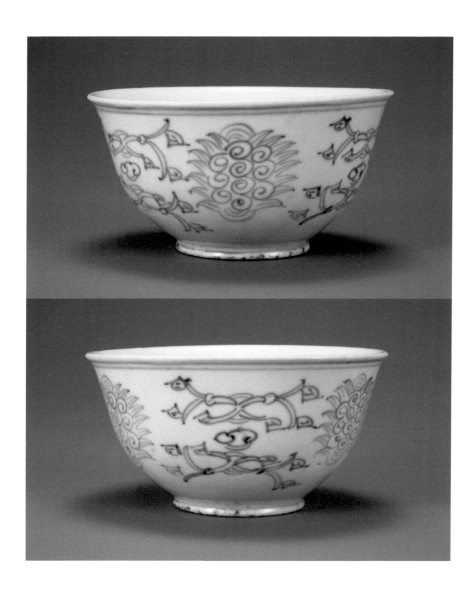

Bowl with Decoration of a Scroll Pattern, 19th century, Joseon,
Porcelain with underglaze cobalt-blue design, h. 8cm, Gyeonggi Ceramic Museum
This short-footed bowl is voluptuous but its outward-flaring lip gives a sense of lightness at the same time.
An exotic floral medallion and scroll pattern design painted on the body of the vessel is brave but
simultaneously sensitive and tidy. The word "*sangsil*" (high place) is painted on the inside of its foot ring,
which indicates that it was made in the royal kiln for the royal family.

Bowl with Decoration of "*Su·Bok·Gang·Ryeong*" Characters, 19th century, Joseon,
Porcelain with underglaze cobalt-blue design, h. 11.8cm, National Museum of Korea
A large circle is painted in cobalt-blue pigment on the center of the wide flat interior bottom of
the bowl. The *bok* character (福) is then inscribed within the circle. The Chinese characters,
su (壽, longevity), *bok* (福, fortune), *gang* (康, health), and *ryeong* (寧, well being) are written
in schematized script to express longevity, wealth, and health.

Bowl with Decoration of Peony, 19th century, Joseon,
Porcelain with underglaze cobalt-blue design, h. 23 cm, Gyeonggi Ceramic Museum
Peony was considered the queen of flowers and was symbolic of wealth. Peony was very
popular motif for everyday porcelain ware with a cobalt-blue design. The peony and its
branches cover the bowl. The flower itself was depicted from an aerial view, as it would be in
folk art painting and embroidery which were very popular at that time.

Container for Courtesy and Leisure: Bottles and Ewers

Since the Three Kingdoms Period when tea settled as an essential part of the Korean culture, ceramic wares have been used as tea vessels. In particular, porcelain has been the choice of pottery for tea since Joseon dynasty. Porcelain has no taste or smell and has a sleek surface, which makes it an ideal clean receptacle for tea. Its subdued yet cheerful color expresses an earnest sense of beauty. There are strict rules and courtesy regarding tea ware (e.g., tea bowls and tea containers) according to the status and class of the user.

Bottles and ewers were used for containing not only tea but also other drinks such as water and wine. In the late Joseon dynasty the so-called *yangban* (gentry) culture where the aristocrats enjoyed incense, tea, stationery, books, antiques, and *bunjae* [a hobby of planting miniature trees in small indoor pots] was widely practiced, and as a result porcelain bottles and ewers became very popular as containers for tea and wine.

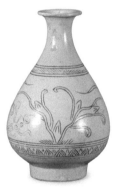 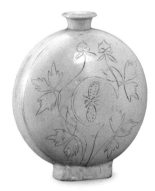

Bottle with Decoration of Floral Scroll, 15th century, Joseon, Soft-paste porcelain with inlaid design, h. 14.7cm, National Museum of Korea
This is a soft-paste porcelain bottle inlaid in black. It has a flaring lip and the body below the neck is voluptuous.

Flask-shaped Bottle with Decoration of Peony and Butterfly, Joseon, Soft-paste porcelain with inlaid design, h. 23.9cm, National Museum of Korea
The soft and gentle tone of the glaze makes the bottle display a light apricot color, which is contrasted to the cold and clean image of hard-paste porcelain. A flask-shaped *buncheong* bottle is usually made by compressing both sides of the body of the vessel. Yet this type of flattened bottle is made by first shaping a shallow cylindrical vessel on a wheel, reorienting it sideways, and attaching the neck and foot.

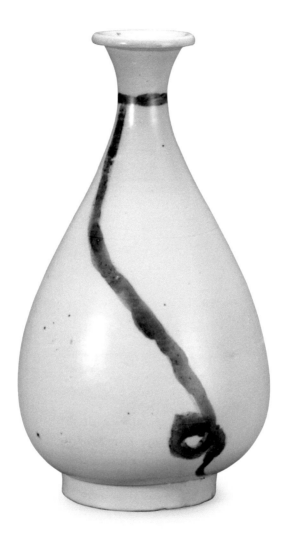

Bottle with Decoration of Cord, 16th century, Joseon, Porcelain,
h. 31.4cm, National Museum of Korea, Treasure no. 1060
This is representative of Joseon porcelain bottles that express a voluptuous body and curve.
The iron-brown painting expresses a cord with that is first wrapped around the neck and dropped
to the bottom with a curling end. The vessel reveals the artist's proficiency and maturity. The
painting gives a leisurely impression with its simplicity and the surrounding ample negative space.
At the same time, the confident and bold stroke reveals the implicit self-assuredness of the artist.

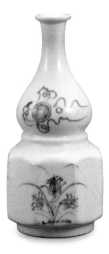

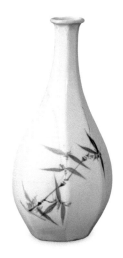

Bottle with Decoration of Seven Trasures and Orchid, late 17th-early 18th century, Joseon, Porcelain with underglaze cobalt-blue design, h. 21.1cm, National Museum of Korea, Treasure no. 1058
This gourd-shaped bottle was a very rare porcelain item and was made by sculpting the vessel to have eight facets in one section. The result is that it looks as though a bottle has been attached on top of the octagonal form. The design was painted in a way that harmonized with the generous negative space. On the top section are decorated a cash and a pair of books, which were two auspicious Chinese patterns. The neat and crisp depiction of an orchid and a China pink on the lower eight-facets manifests the Korean spirit.

Octagonal Bottle with Decoration of Chrysanthemum and Bamboo, late 17th-18th century, Joseon, Porcelain with underglaze cobalt-blue design, h. 27.5cm, National Museum of Korea
This bottle has a round and elegant body and a long neck. It was carved to have eight facets from the foot all the way to the lip. The harmony between a simple yet elegant design in cobalt-blue on transparent white body and the translucent glaze with a slight blue undertone is refreshing. The glaze has been applied thick and there is no crackle pattern.

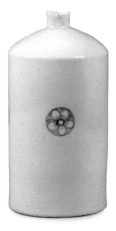

Bottle with Decoration of Pear Flower, late 19th-early 20th century, Joseon, Porcelain with underglaze cobalt-blue design, h. 20.6cm, National Museum of Korea
This bottle exhibits disciplined simplicity with its profile consisting of the sleek cylindrical body form, round shoulders, and a narrow opening. The small simple design of a pear flower in the center of the body is consistent with the minimal profile of the vessel. This pear flower design was a symbol of the imperial family of the Korean Empire, which indicates that this bottle was used by the imperial family.

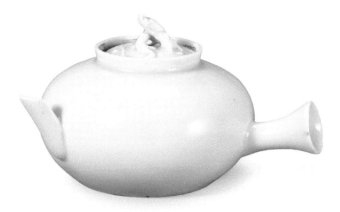

Teapot, 19th century, Joseon, Porcelain, h. 10.1cm, National Museum of Korea, Treasure no. 1058
This tea pot has a bugle-shaped handle on one end and a spout on the other end. The lid of the pot is decorated with *banryong* (dragon that is left on the earth having failed to fly into the heaven). The ice blue glaze, a signature glaze of the 19th century royal kiln, has been carefully applied to the body to display a smooth surface and gentle brightness.

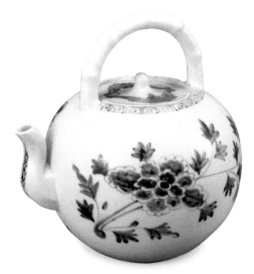

Teapot with Decoration of Peony, 19th century, Joseon, Porcelain with underglaze cobalt-blue design, h. 19.8cm, Gyeonggi Ceramic Museum
Traditionally, porcelain beverage vessels were made into bottles rather than into teapots. This was because with the low plasticity of white clay simple vessel profiles were preferred. However, the advancing technology for making porcelain and the popularity of Western style teapots in the late Joseon dynasty led to the production of porcelain teapots with various shapes. This teapot has a round voluptuous body to which is attached a bamboo-stem-shaped handle and a short angular spout. The harmony between lines and curves imparts a sense of suspension to the overall shape of the teapot.

From Birth to Death:
Ritual Objects

The widespread acceptance of Neo-Confucianism made great contribu-
tion to the development of porcelain ritual objects, a large volume of which
were produced during the Joseon dynasty. In the Joseon dynasty public
ceremonies were practiced by the royal family, *jongmyo* (shrines), *kwanga*
(government offices), *hyanggyo* (local government schools), *yurim* (Confu-
cian scholars), and *seowon* (local private schools) while private ceremonies
in the form of ancestral rites were practiced in individual households.

Porcelain ritual objects were divided by function into the following: the
vessels used for containing water and wine, vessels that stored ritual goods
and food, and the objects used for incense burners. The types and shapes
of the objects were strictly regulated depending on the nature and scale of
a ceremony or ritual. Most of the porcelain ritual vessels have a high foot,
which signified deep reverence for ancestors.

Other rite or ceremony related vessels include placenta jars and burial
objects called *myeonggi*. Placenta jars were used to contain the placenta of
a new born baby usually of a royal family. Typically, the baby's placenta was
put in a small "interior" jar, which was then placed in a larger "exterior" jar,
which was buried in a placenta burial site called *taeji* along with a placenta
tablet. For this reason, placenta jars had a lid with a device that allowed a
cord to seal it. These jars were treated with strict and serious manners.

Porcelain burial objects were ritual objects used for life in the next
world. That is, they were buried along with the deceased with a wish for
the deceased to rest in peace in the next world. The items that were typi-
cally buried were the vessels thought to be used by the deceased in the next
world, figures in the shape of the family members or domestic animals of
the deceased and occasionally porcelain memorial stones that recorded the
deceased person's life and the location of his burial site.

Burial Figures, 17th century, Joseon, Porcelain painted in
underglaze iron-brown, h. 6.6-8.7cm, National Museum of Korea
Joseon burial objects were often made in a reduced scale in
accordance with the size of the grave. They may be divided into
every day vessels (e.g., shallow bowls, dishes, and lidded jars)
and articles in the shape of people and animals (e.g., horses and
donkeys). The burial objects in this photo depict servants putting
their hands together in a deferential manner. Each character
displays a different facial expression. The iron-brown painting
of the eyes, nose, mouth, and hair adds reality to the characters.

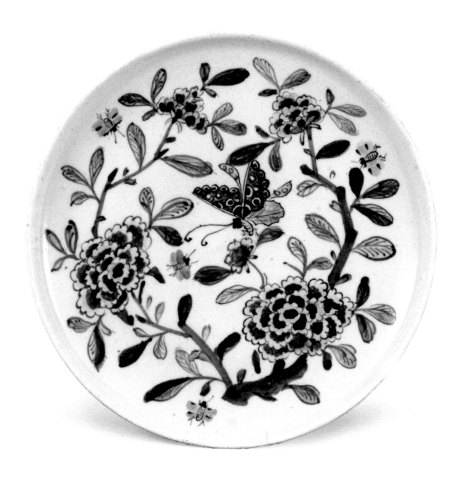

Ritual Vessel with Decoration of China Rose,
19th century, Joseon, Porcelain with underglaze
cobalt-blue design, h. 9.3cm, Horim Museum
In general, the production of ceremonial vessels
complied with rigorous regulations. However, 19th
century Korea began to witness ceremonial vessels
that broke the conventional rules, such as this vessel.
The interior floor of this dish is opulently decorated
with large China roses and stems with bees and
butterflies painted among them. The swastika motif
decorates the pedestal on four sides with openwork
technique which heightens the elegance of the vessel.

Ritual Vessel, 17th-18th century, Joseon, Porcelain, h. 10.8cm, National Museum of Korea
This vessel, called *bo*, was used to serve rice and hog millet. According to *Jegidoseol* (a *Book on Ceremonial Vessels*), a *bo* is originally made of bronze and has a rectangular shape, which was decorated with animals on the four sides and further adorned with thunder and wave design. This *bo* is porcelain version of the original; the original corner angles were tempered to a round shape and the animal design was replaced by a ring.

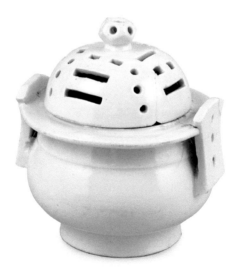

Incense Burner with *Geon·Gon·Gam·Ri* **Trigrams**, 19th century, Joseon, Porcelain with openwork design, h. 115cm, National Museum of Korea
The body section used to burn incense as a ceremonial incense burner has a high foot, a wide lip, and a rotund body. A handle with three holes and a pointed tip is attached to each side of the burner. The lid has a semi-circular shape with *geon-gon-gam-ri* trigrams [≡ ≡≡ ≡≡ ≡≡] with openwork technique around it. The knob of the lid is pentagonal and has a design with openwork technique. A thick layer of ice blue glaze has been applied to the burner.

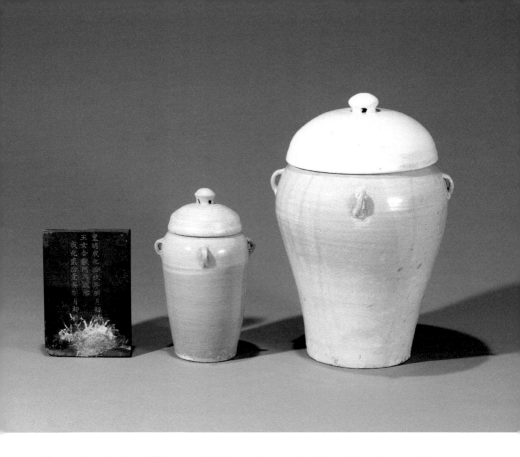

Placenta Jar and a Memorial Stone, ca. 1485, Joseon, Porcelain, h. 42.5cm, National Museum of Korea
It was the Joseon royal family's custom to put a new born baby's placenta in a jar and bury it in a placenta grave. They carefully chose an auspicious day to put the placenta first in the so-called "interior" small jar, which was then placed in the larger "exterior" jar. The jar was buried along with a memorial stone which recorded the baby's birthday and the date of placenta burial. The burial rite was completed by erecting a *taebi*, a tombstone for the placenta. According to the placenta stone, this placenta belonged to Lady Hap-hwan whose birth year and placental burial year were 1483 and 1485, respectively.

Scholars' Companion: Stationery Objects

The spirit of *mun-bang-cheong-wan* (stationery-room-blue-complete) which strives for a crisp atmosphere free of secular air by cultivating a proper study place was a long tradition among Korean scholars. They pursued a high intellectual ideal by taking leisure, which was reflected in their trivium arts activities of *si-seo-hwa* (poetry-calligraphy-painting). Such *han-muk-jeong-chui* spirit (spirit of letters represented by a brush and an inkstone) developed into elegant hobbies of cherishing stationery items such as inkstones and water droppers.

In Korea various stationery objects were widely used as early as the Three Kingdoms period. While the stationery of the Three Kingdoms period was low-fire, that of Goryeo dynasty was celadon. Later during Joseon dynasty porcelain stationery became even more popular thanks to the widespread acceptance of Neo-Confucianism. In particular, in the late Joseon with the expansion of commerce the hobby of collecting items such as stationery, calligraphy books, antiques, *bunjae* pots, and stones became very popular among the wealthy aristocrats and even the commoners. The so-called *pungryu* (leisure) culture of visiting scenic places and enjoying incense, tea, and poetry-calligraphy- paintings (*si-seo-hwa*) was established. Such a socio-cultural change brought an innovative and new trend of art and design to the ceramic industry. As a result, a variety of porcelain stationery objects such as brush holders, water droppers, brush washing basin, incense burners, and water basin were manufactured.

Knee-shaped Water Dropper, Joseon, Porcelain, h. 11.2cm, National Museum of Korea
This is called "knee water dropper" because its round top resembles the human knee. It is a pretty water dropper with a petit spout attached to its side. The glaze with a light blue tone, a trademark of the royal kiln of the 19th century, was evenly applied to the body to exhibit a clean surface and gentle brightness. A clean surface, a disciplined simple body, and a simple foot represent the highly disciplined aesthetics of the scholars of this period.

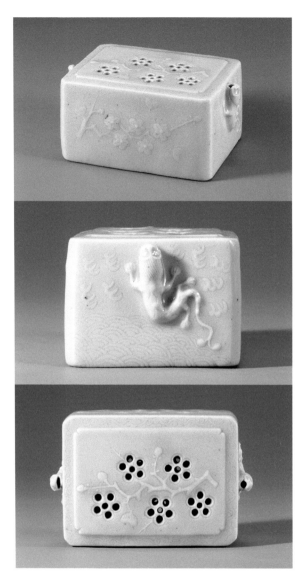

Water Dropper with Decoration of Plum Blossoms, Joseon, Porcelain
with raised carving technique, h. 5.5cm, National Museum of Korea
Many stationery articles popular in the late Joseon are highly ornamented
with diverse techniques. The orchid design of this rectangular water
dropper is made by piercing the vessel; yet an extra interior wall is built
to prevent water leakage. Its elegantly simple shape and the skillful
design manifest the artist's high aesthetics. The glaze and clay used are
also top quality. The water dropper's overall high quality indicates that it
was made in the royal kiln upon a special request by the royal family or
another powerful family.

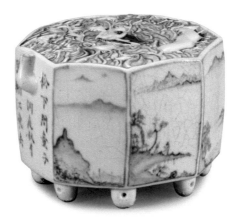

Octagonal Water Dropper with Decoration of the Eight Views of Xiaoxiang, 19th century, Joseon, Porcelain with raised carving technique and underglaze cobalt-blue design, h. 12.6cm, National Museum of Korea, Treasure no. 1329
This large octagonal water dropper has the Eight Views of Xiaoxiang design on all facets. The Eight Views of Xiaoxiang refers the paintings which portrayed the eight breath taking views of Xiang River and Xiao River regions in the south of Dongting Lake in Hunan Province, China. As this painting became very popular in the scholar class in the late Joseon dynasty, it was commonly used as a feature for porcelain with a cobalt-blue design.

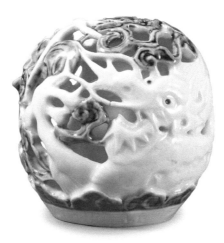

Water Dropper with Decoration of Cloud and Dragon, Joseon, Porcelain with openwork and underglaze cobalt-blue design, h. 11. 5cm, National Museum of Korea
This relatively large water dropper was placed on a stationery chest or a table for appreciation. Its shape is similar to that of a "knee-shaped water dropper" and has a double-walled body with a peach-shaped interior structure used for containing water and an ornamental exterior structure. A cloud and dragon design is confidently engraved with openwork technique on the surface of the exterior wall. Cobalt-blue pigment is painted only on the sky, which contrasts with the dragon. This water dropper exhibits the artist's aesthetic sensibility and aptitude.

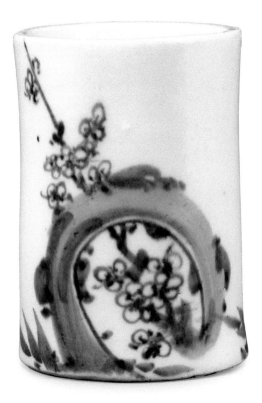

Brush Holder with Decoration of Plums and Bamboos, Joseon,
Porcelain with underglaze cobalt-blue design, h. 12.7cm, National Museum of Korea
This simple brush holder has a plum design on one side and a bamboo design on the other
side. Even though the painting is small, it is no less impressive than a large painting.
The paintings used as a design motif for porcelain with cobalt-blue designs were originally
created by painters of *Dohwaseo* (the royal bureau of painting). The cobalt-blue plum
design is so refreshing that one might even smell the scent of the flower.

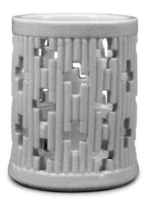

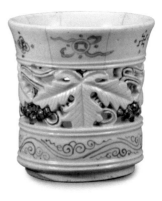

Bamboo-stem-shaped Brush Holder with Decoration of Cross, 19th century, Joseon, Porcelain with openwork design, h. 12cm, National Museum of Korea
The base section of this brush container subtly flares. First, deep vertical furrows were made with regulated negative space between them to give the effect that the container was tightly woven with a thin layer of bamboo. Then cross-shaped forms were carved out every two or three lines. Glaze with a very light blue tone was evenly coated on the vessel.

Paper Holder with Decoration of Grapes, late 18th century, Joseon, Porcelain with openwork design, h. 15.8cm, National Museum of Korea
This vessel was used for holding scrolled paper. Its lip is slightly flared and the body is straight down to the base where it flares slightly. The design of an auspicious pattern and vine design is painted on the upper and lower sections, respectively, with engraved grapes and vines. Openwork technique was used for the background. The glaze displays a warm tone and a gentle blue tint.

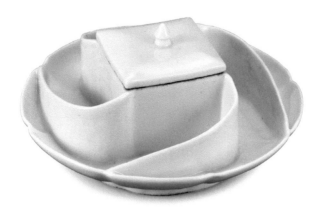

Brush Washbasin, 19th century, Joseon, Porcelain, h. 8cm, National Museum of Korea
This vessel was used to wash brushes or adjust the concentration of ink. The basin has a flower shape and a lidded lotus-bud-shaped water container in the center. From each corner of the rectangular water container begins a nautilus shell shaped partial basin. With its elegant simplicity it is one of the most beautiful Joseon washbasins.

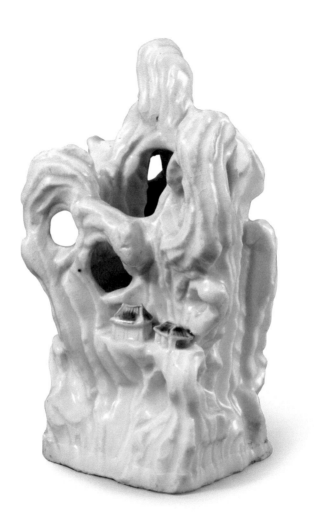

Mountain-shaped Brush Hanger, 19th century, Joseon,
Porcelain with underglaze cobalt-blue design, h. 23.5 cm, National Museum of Korea
This brush hanger has the shape of a rugged mountain with two houses at its base. It reflects the artist's bold and eloquent technique as well as an excellent sense of art and design; it is perfectly appropriate as an item in *sarangbang* (men's quarter) of a Joseon scholar's house. The artist created contrast by painting the roof of the houses with cobalt-blue. The glaze is white with a light blue tint and has a high gloss, which was a signature of the royal kiln in the 19th century.

Korean Porcelain of Today

Porcelain of today which carries the labor intensive tradition of the past may be divided into two schools. One is the school of "porcelain from heritage and tradition" developed on the basis of regional tradition, practiced in such places as Icheon, Yeoju, Danyang, Mungyeong, Sangju, Gijang, Gimhae, Cheongsong, and Yanggu. The other is the school of "porcelain of tradition·function·sculpture" which centers around academia. The latter has made great contributions adding modern and practical value to traditional porcelain.

Particularly, figurative or sculptural porcelain as a new genre has exhibited several experimental works that supported its recognition as a legitimate form of contemporary art. At the turn of the 20th century the West witnessed a renaissance movement of ceramic art as a rebellion against the standardized and uniform life style and culture which resulted from the mass production system introduced after the Industrial Revolution. Through this movement ceramic ware was recognized as a part of pure art, which was later expressed in such diverse forms as abstract expressionism, funk ceramics, super-real Trompe-l'oeil ceramic art, and ceramic sculpture.

Since the 1960s Korean porcelain has been in active communication with the contemporary art trends of the world, which led to the birth of porcelain fine art which announced the birth of Korean porcelain as a part of contemporary art, distinct from both traditional craftsman porcelain and factory-produced porcelain. In addition to the conventional method using a wheel, figurative ceramic art adopted diverse techniques of shaping such as sculpting and casting techniques. The medium of ceramic ware including porcelain draws inspiration from other genres of art such as sculpture, painting, and design and expresses new art concepts and values in the medium of clay. In addition, contemporary ceramic art reveals an experimental spirit by incorporating other materials and forms of media (e.g., wood, glass, photos, and video images).

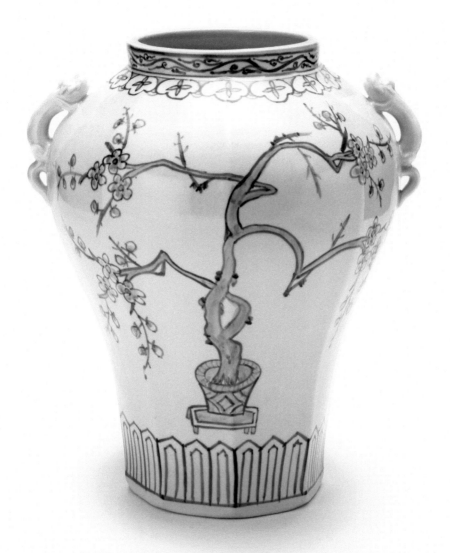

Octagonal Jar with Decoration of Plum Blossoms, Seo Kwangsu (designated as Intangible Cultural Heritage of Gyeonggi-do and Master of Korea), 2010, Porcelain with underglaze cobalt-blue design, h. 37cm
Seo emulates producing pottery with traditional methods for over fifty years. He tried to replicate the shapes and designs of the 18th century porcelain of the royal kiln. This vessel was carved to have an octagonal shape, and squirrel-shaped handles (squirrels are symbolic of abundant offspring) are attached to the shoulder of the vessel. On the surface is painted a plum *bunjae* pot design with cobalt-blue pigment. Even though the jar is brighter and neater than the original Joseon porcelain jar, it still gives the fresh and solemn air found in the original.

Jar with Decoration of Peonies, Han Ilsang (Master of Gwangju-si), 2011,
Porcelain with underglaze cobalt-blue design, h. 85cm
Han has continued the tradition of Joseon porcelain. He is especially renowned for his porcelain with a cobalt blue design. This jar is the master's reconstruction of a Joseon ceremonial vessel, *hwajun* (flower vase). He ornately carved the lower part of the jar into an octagonal shape, and the body is decorated with peonies in folk painting style and cloud-and-crane. It seems as if he wanted to amplify the opulent beauty hidden in Joseon porcelain.

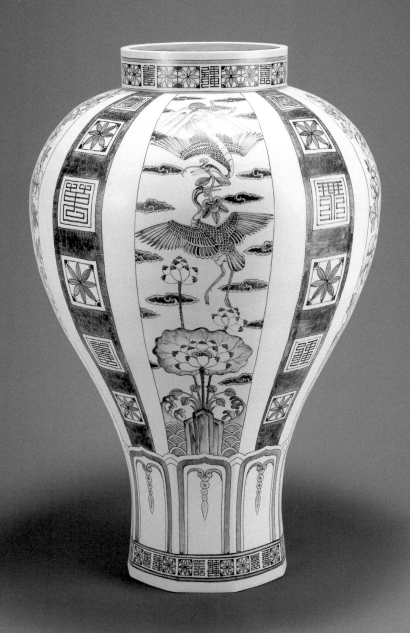

Octagonal Jar, Kim Jeongok (Important Intangible Cultural Heritage, Master of Korea), 2012, Porcelain, h. 37cm
As a ceramic master Kim has been awarded the title of Important Intangible Cultural Heritage. His grandchildren are the ninth generation that practices the tradition of Joseon porcelain. His struggle between the desire to continue the tradition and to transcend the tradition is reflected in his works. For instance, this jar, although it has the traditional shape of a moon jar of the late Joseon period with its upright mouth, its facetted body adds a new aspect to traditional Joseon porcelain.

Jar with Decoration of Persimmon, Lim Hangtaek (Master of Korea), 2013, Porcelain with underglaze copper-red and gold design, h. 51cm
Lim is famous for his porcelain with a gold copper-red design. This jar with a copper-red design was also fired in the traditional way in a kiln burning pinewood. Its translucent scarlet red design is simply impressive.
The persimmon tree branches which harmonize with negative space form a perfect union with the lively and sleek profile of the jar.

Moon Jar, Park Buwon (Master of Gwangju-si), 2012, Porcelain, h. 51cm
Park reveals aesthetic principles of Joseon porcelain through soft creamy color shades and generous shape. This moon jar was made using coiling method which was often used in making *onggi*. It opens a communion through which we can connect to Korean masters who sustained the ceramic tradition from clayware built by coiling technique to Goryeo celadon to Joseon porcelain.

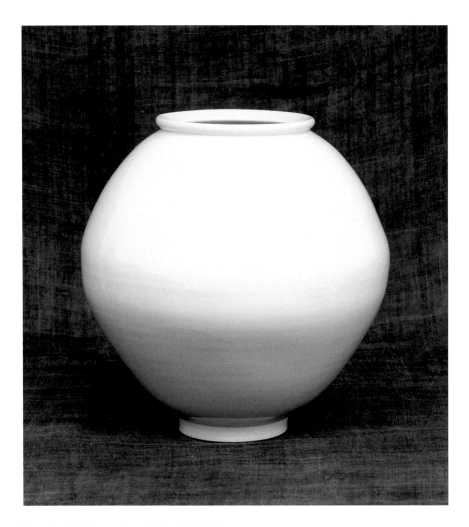

Moon Jar, Park Youngsook, 2003, Porcelain, h. 58cm
Park first became famous for her contemporary style porcelain dishes and ewers. Later she became more recognizable for her large vessels that transcended the limits of Joseon porcelain. Her moon jars are large and durable. This jar has been smoothed numerous times to have a voluptuous and sleek body. While large, this jar still feels delicate rather than heavy, which reminds us of the calm axis in the center of a fast spinning wheel.

Rectangular Waterbasin, Lee Geejo, 2013, Porcelain slap-built, h. 26cm
The confident expression of the naked beauty of porcelain without any decoration is the root of Lee's artistic work. Lee has always been interested in the properties of porcelain and approaches his work by maximizing the beauty of the material itself. This abstract construction was made by joining hand-kneaded clay slabs. Although this work has a simple shape like that of Joseon porcelain, its message is far from being simple.

Bowl with Decoration of Clouds, Lee Yeongho, 2009,
Porcelain with underglaze cobalt-blue design, h. 9.3cm, Gyeonggi Ceramic Museum
Lee is very familiar with porcelain and its matiere. His insistence on "vessels" keeps him producing ceramic ware that is functional. Through his works he strives for a simple and concise profile. His works reveal his deep understanding of and familiarity with lines, which is attributable to his persistent interest in the organic harmony expressed in the lines of Joseon porcelain. The contrast between two similar bowls with a cobalt-blue design is refreshing.

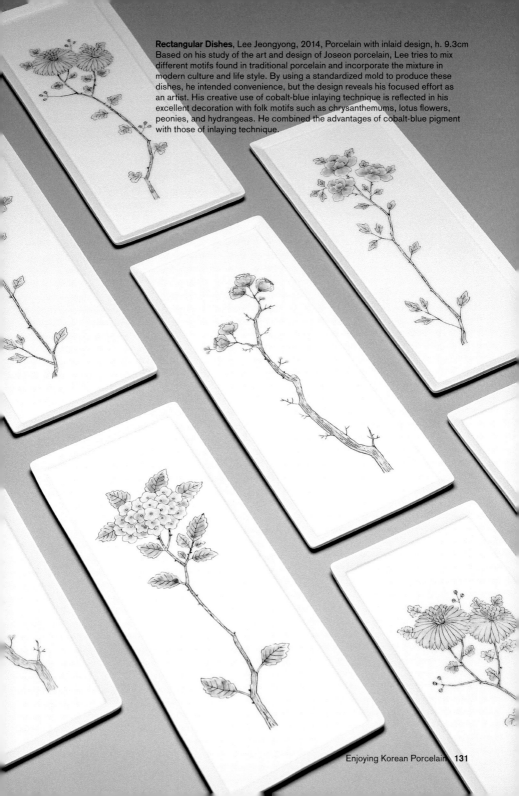

Rectangular Dishes, Lee Jeongyong, 2014, Porcelain with inlaid design, h. 9.3cm
Based on his study of the art and design of Joseon porcelain, Lee tries to mix
different motifs found in traditional porcelain and incorporate the mixture in
modern culture and life style. By using a standardized mold to produce these
dishes, he intended convenience, but the design reveals his focused effort as
an artist. His creative use of cobalt-blue inlaying technique is reflected in his
excellent decoration with folk motifs such as chrysanthemums, lotus flowers,
peonies, and hydrangeas. He combined the advantages of cobalt-blue pigment
with those of inlaying technique.

Large Bowl, Han Jeongyong, 2014, Porcelain, h. 15cm
Han understands the importance of the raw materials of porcelain. He pursues technically flawless contemporary porcelain by using white clay whose density exceeds that of the traditional white clays. The pooling of glaze and bending of the vessel body are the results of the artist's meticulous calculation, which he harmonizes with the natural beauty bestowed by artful design.

Ewer, Chung Yountaeg, 2003, h. 14.2cm, Gyeonggi Ceramic Museum
Chung is both a researcher and explorer in Korean porcelain. He seeks modern motifs in Joseon porcelain and turns them into elements of 21st century porcelain by imposing a minimal change to them. This ewer is soft and voluptuous with a neat and stable shape. Despite its modest size it fully expresses the beauty of the design. The artist's personal touch to the teapot offers a warm impression while other porcelain pitchers tend to feel cold.

Melon-shaped Tea Set, In Hyunsik, 2014, Porcelain with ribbed design, h. 10cm (ewer)
Mr. In's work which revolves around tea equipment reveal the artist's refreshing sensibility and a high degree of cohesiveness. To maximize the design and practical aspects of the work he is willing to reject traditional methods of making porcelain and explore new methods and materials. His work allows us to envision the future of Korean porcelain. Another characteristic of his art is that he is always in search of different techniques for combining porcelain with other materials such as metals, glass, and wood.

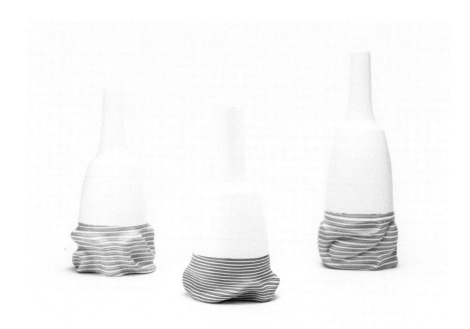

Bottles, Cho Sinhyun, 2013, Porcelain, h. 28-38cm
The signature style of Cho is stacking and carving clay slabs of different colors to create various shapes and changes in rhythm. Although this technique was used for making Goryeo marble celadon, the end product is quite different. These bottles were made with that same method. The artist created a ruffle-shaped outline on the surface of layered slabs. This kind of expression, which resembles the properties of nature, is uniquely possible with ceramic ware.

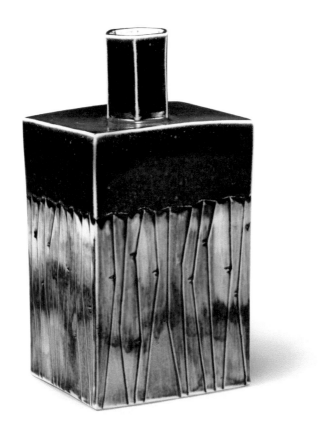

Rectangular Bottle, Kim Kyutae, 2009, Porcelain with underglaze cobalt-blue and copper-red design, h. 22cm, Gyeonggi Ceramic Museum

Copper-red is a preferred pigment for few artists because it is not easy to get the intended color and also since it is too bold a color for everyday ware. However, Kim specializes in copper-red; he is drawn to bold red and cobalt-blue. This bottle was inspired by late Joseon porcelain facetted bottle with a cobalt-blue design but its shape and color reveal the artist's own interpretation. The way its surface is carved makes one feel the weight of clay.

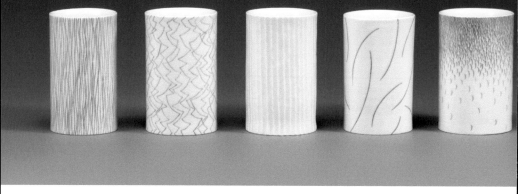

Brush Holder, Jung Jaehyo, 2013, Porcelain with inlaid design, h. 12cm
During his apprenticeship Jung emulated Joseon vessels, especially rough low quality porcelain and
buncheong ware. For this reason his porcelain works are attractive and offer a warm impression.
He incised the outer walls of the simple cylindrical vessel and filled the furrows with blue colors. Even though
sophisticated methods such as using cobalt-blue and inlaying technique were employed, the containers still
feel concise and elegant rather than opulent. One can tell the artist's distinct approach to art: while cherishing
tradition, he reinterprets it in a manner that is uniquely his.

Brush Holder, Han Ikhwan, 1990, Porcelain with underglaze cobalt-blue design, h. 16cm
Han has devoted his entire life to reconstructing Joseon porcelain and is arguably the best that has done so.
The grace and depth of Joseon porcelain of the 18th century Geumsa-ri royal kiln is revived in this porcelain
cup. This cup, despite its apparent simple shape and design, is recognized as an excellent work that expresses
the earnest and solemn beauty embedded in Joseon porcelain.

Incense Burner (left) and Lidded Jar (right),
Lee Dongsik, 2012, Porcelain with cobalt-blue design,
h. 7cm (left), h. 12.5cm (right)
Lee has been fascinated by the elegance of Joseon
porcelain and was influenced by its unique colors and
large shapes even in the absence of ornamentation, and
he wants to reproduce such beauty. Porcelain whose
profile is voluptuous yet elegant and has a gentle color
that does not impose a sense of being; this is the kind
of porcelain that elevates us. This porcelain set with its
balanced shape and appealing cobalt-blue design will
mingle well in any setting.

Pencil Holder, Lee Changhwa, 2011, Porcelain, h. 13cm
Lee has been drawing attention for his practical yet
innovative and unique design. He makes innovate shapes
using slip casting and a wheel, and his free-spirited use
of cobalt-blue and copper-red adds intensity to his works.
It is as if he resides in both worlds of fine art and craft.
This pencil holder has no decoration; it faithfully serves its
purpose with a simple functional shape. It could easily be
regarded as a piece of craft work.

Ceramic Domain, Kim Yikyung, 2001, Porcelain, h. 120cm (tallest)
Kim has been diligently researching Joseon porcelain and tries to discover the essence of Joseon porcelain through careful examination. She is always eager to emphasize the importance of traditional ceramics to her students. This work was inspired by the rectangular ritual vessel of the Joseon dynasty. Her endeavor to realize the deep and earnest beauty of porcelain is witnessed in the simplified shape and rough surface.

Untitled, Kang Sukyoung, 2001, Porcelain, ea. 84x10x10cm, Korea Ceramic Foundation
Ceramic ware is abstract art in itself. Kang materializes abstract qualities in the vessels based on his understanding of their properties, which adds to the cohesiveness of his works. These cones are created by altering and positioning the vessels made by slip casting method in different manners. The texture and marks of forced alteration are reminiscent of primitive nature.

TAO LB422013, Lee Seunghee, 2013, 100x83cm
Lee creates two-dimensional ceramic work, using traditional ceramic ware technique. Such traditional objects as the inkstones of Goryeo and Joseon dynasties, cobalt-blue design porcelain, and moon jars are reflected in Lee's works in a quite different manner. By eliminating the realization of ceramic ware as a three-dimensional object, the two-dimensional aspect is emphasized. This bas-relief was made by drawing a vessel on the canvas of a clay plate made by coating the surface with slip 60-70 times. Lee's works belong to both worlds of ceramics and painting by being two-and three-dimensional simultaneously.

Untitled (front), Baek Jin, 2013, Porcelain, h. ea. 51cm
A Drop (wall piece), Baek Jin, 2013, Porcelain, 900×400×5cm
Based on her understanding of refined white clay, she crumples porcelain slabs or conjoins the pieces as if they were paper, through which the light and shape of the porcelain is displayed repeatedly. Each piece hand-shaped as a Möbius strip forms a colony on a plane to create an exaggerated sense of space. The distinct properties of porcelain make this kind of expression possible.

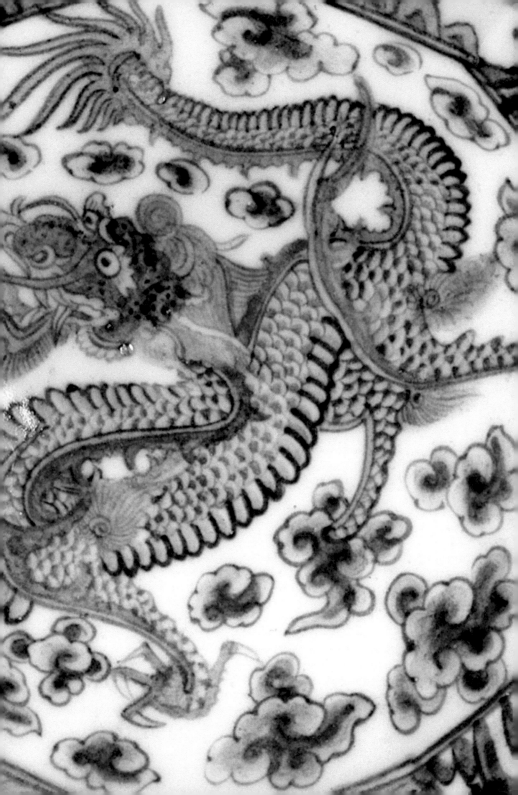

Reference

List of Masters

The traditions and techniques of Korean porcelain have been passed down by the following masters. Kim Jeongok, running a ceramic business for a seventh generation in Gwaneum-ri, Mungyeong, was designated as an Important Intangible Cultural Heritage Master of Ceramic Ware in 1996. The title of Regional Intangible Cultural Heritage Master of Ceramic Ware was awarded to Seo Donggyu (Danyang), Baek Younggyu (Goryeong), and Seo Kwangsu (Icheon). The title of Master of Korea (porcelain) was awarded to Kim Jeongok, Cheon Hanbong (Mungyeong); Seo Donggyu (Danyang); Seo Kwangsu, Lim Hangtaek, Gwon Taehyeon (Icheon); and Han Wansu (Sacheon).

Important Intangible Cultural Heritage (Nov. 2014)

No.	title	name	date of recognition
105	Master of Ceramic Ware	Kim Jeongok	July 1, 1996

Intangible Cultural Heritage of the Province (Nov. 2014)

region	No.	title	name	date of recognition
Chungcheongbuk-do (Danyang)	10	Master of Ceramic Ware	Seo Donggyu	October 25, 2002
Gyeonggi-do (Icheon)	41	Master of Ceramic Ware (porcelain)	Seo Kwangsu	February 7, 2005
Gyeonggi-do (Yeoju)	41-1	Master of Ceramic Ware (porcelain with a cobalt-blue design)	Han Sanggu	February 7, 2005
Gyeongsangbuk-do (Woonsu-myeon, Goryeong)	32-3	Master of Ceramic Ware (porcelain)	Baek Younggyu	November 5, 2009

Craft & Design Map

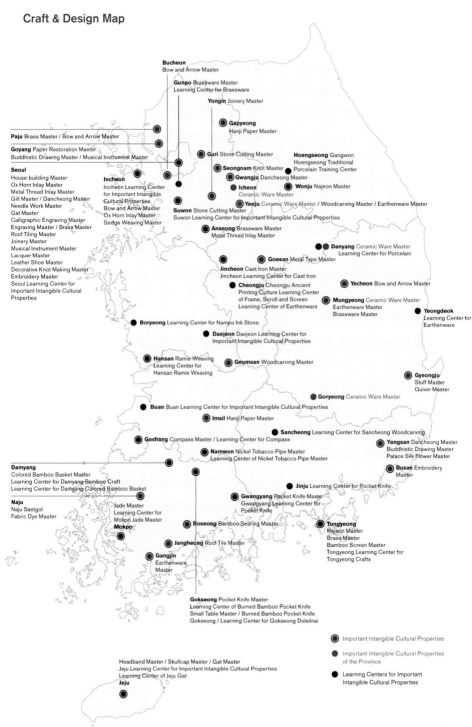

Bucheon Bow and Arrow Master

Gunpo Brassware Master
Learning Center for Brassware

Yongin Joinery Master

Gapyeong Hanji Paper Master

Paju Brass Master / Bow and Arrow Master

Goyang Paper Restoration Master
Buddhistic Drawing Master / Musical Instrument Master

Seoul
House-building Master
Ox Horn Inlay Master
Metal Thread Inlay Master
Gilt Master / Dancheong Master
Needle Work Master
Gat Master
Calligraphic Engraving Master
Engraving Master / Brass Master
Roof Tiling Master
Joinery Master
Musical Instrument Master
Lacquer Master
Leather Shoe Master
Decorative Knot Making Master
Embroidery Master
Seoul Learning Center for
Important Intangible Cultural
Properties

Incheon
Incheon Learning Center
for Important Intangible
Cultural Properties
Bow and Arrow Master
Ox Horn Inlay Master
Sedge Weaving Master

Guri Stone Cutting Master

Seongnam Knot Master

Gwangju Dancheong Master

Icheon Ceramic Ware Master

Yeoju Ceramic Ware Master / Woodcarving Master / Earthenware Master

Hoengseong Gangwon
Hoengseong Traditional
Porcelain Training Center

Wonju Najeon Master

Suwon Stone Cutting Master
Suwon Learning Center for Important Intangible Cultural Properties

Anseong Brassware Master
Metal Thread Inlay Master

Goesan Metal Type Master

Danyang Ceramic Ware Master
Learning Center for Porcelain

Jincheon Cast Iron Master
Jincheon Learning Center for Cast Iron

Cheongju Cheongju Ancient
Printing Culture Learning Center
of Frame, Scroll and Screen
Learning Center of Earthenware

Yecheon Bow and Arrow Master

Mungyeong Ceramic Ware Master
Earthenware Master
Brassware Master

Yeongdeok
Learning Center for
Earthenware

Boryeong Learning Center for Nampo Ink Stone

Daejeon Daejeon Learning Center for
Important Intangible Cultural Properties

Hansan Ramie Weaving
Learning Center for
Hansan Ramie Weaving

Geumsan Woodcarving Master

Gyeongju
Stuff Master
Quiver Master

Buan Buan Learning Center for Important Intangible Cultural Properties

Imsil Hanji Paper Master

Goryeong Ceramic Ware Master

Sancheong Learning Center for Sancheong Woodcarving

Gochang Compass Master / Learning Center for Compass

Yangsan Dancheong Master
Buddhistic Drawing Master
Palace Silk Flower Master

Namwon Nickel Tobacco Pipe Master
Learning Center of Nickel Tobacco Pipe Master

Busan Embroidery
Master

Damyang
Colored Bamboo Basket Master
Learning Center for Damyang Bamboo Craft
Learning Center for Damyang Colored Bamboo Basket

Jinju Learning Center for Pocket Knife

Gwangyang Pocket Knife Master
Gwangyang Learning Center for
Pocket Knife

Naju
Naju Saetgol
Fabric Dye Master

Jade Master
Learning Center for
Mokpo Jade Master
Mokpo

Boseong Bamboo Searing Master

Tongyeong
Najeon Master
Brass Master
Bamboo Screen Master
Tongyeong Learning Center for
Tongyeong Crafts

Jangheung Roof Tile Master

Gangjin
Earthenware
Master

Gokseong Pocket Knife Master
Learning Center of Burned Bamboo Pocket Knife
Small Table Master / Burned Bamboo Pocket Knife
Gokseong / Learning Center for Gokseong Dolsilnai

Important Intangible Cultural Properties

Important Intangible Cultural Properties
of the Province

Learning Centers for Important
Intangible Cultural Properties

Headband Master / Skullcap Master / Gat Master
Jeju Learning Center for Important Intangible Cultural Properties
Learning Center of Jeju Gat
Jeju

List of Photos

Cover
Jar, 15th century, Joseon, Porcelain, h. 25cm, National Museum of Korea

h. 19.5cm, National Museum of Korea

Jar with Decoration of Floral Scrolls, late Joseon, Porcelain painted with underglaze cobalt-blue, h. 11cm, Yanggu Porcelain Museum

Drum-shaped Bottle, 15th-16th century, Joseon, Porcelain, h. 21.2cm, Gyeonggi Ceramic Museum

Round Porcelain Rice Cake Mold with Decoration of Flowers, 19th century, porcelain, h. 3cm, Konkuk University Museum

Round Porcelain Rice Cake Mold with Decoration of Flowers, 19th century, porcelain, h. 6.9cm, Konkuk University Museum

Rectangular Porcelain Rice Cake Mold with Decoration of Flowers, 19th century, porcelain, h. 5cm, Konkuk University Museum

p.26 Placenta Tablet with Inscription of "*cheon gye yungnyeon*", ca. 1626, Joseon, Porcelain, h. 4.2cm, National Museum of Korea

Horse-shaped Burial Accessory, Joseon, Porcelain, h. 4.5cm, Yanggu Ceramic Museum

Ritual Vessel, Joseon, Porcelain, h. 21cm, National Museum of Korea

Placenta Jar, Joseon, Porcelain, h. 25cm (left), 35.7cm (right), National Museum of Korea

p.27 Brush Holder with Decoration of Plum Blossoms and Bats, Joseon, Porcelain with raised design, h. 11.2cm, National Museum of Korea

Lidded Incense Burner with Decoration of a Lion, 19th century, Joseon, Porcelain, h. 15.7cm, Gyeonggi Ceramic Museum

Flower Pot with Decoration of Plum, Pine Tree, and Bird, late Joseon, Porcelain painted with underglaze cobalt-blue, h. 12.5cm, Yanggu Ceramic Museum

Smoking Pipe with a "*Su* (long life)" Character Design, 19th century, Joseon, Porcelain, h. 5.3cm, Haegang Ceramics Museum

p.28 Lidded Bowl, Goryeo, Porcelain, OAH 3.8cm, National Museum of Korea

Lamp, early 20th century, Porcelain, h. 6cm, Yanggu Ceramic Museum

Candlesticks, 19th century, Joseon, Porcelain, h. 18cm, Gyeonggi Ceramic Museum

p.29 Sun Dial with Decoration of Twelve Zodiac Signs, 19th century, Joseon, Porcelain with underglaze cobalt-blue design, h. 6.6cm, Haegang Ceramics Museum

Godeuretdol Weight, early 20th century, Porcelain, h. 6.5cm, Yanggu Ceramic Museum

Yakyeon (druggist's mortar), 18th century, Joseon, Porcelain, h. 6.6cm, National Museum Korea

Ink Container, Joseon, h. 5.8cm, National Museum of Korea

p.31 Comb-pattern Terra-cotta, Neolithic Age, h. 38.1cm, National Museum of Korea

Burnished Red Terra-cotta , Bronze Age, h. 15cm, National Museum of Korea

Warrior on Horseback, Silla, h. 26.8cm, National Museum of Korea, National Treasure no. 91

Gourd-shaped Celadon Ewer Inlaid with Peony Vine Design, 12th century, Goryeo, h. 34.3cm, National Museum of Korea, National Treasure no. 116

Buncheong Jar Inlaid with a Cloud and Dragon Design, 15th century, Joseon, h. 48.5cm, National Museum of Korea, National Treasure no. 259

p.32 Bottle with a Peony and Willow Tree Design, 12th century, Goryeo, Porcelain with inlaid decoration, h. 28.8cm, National Museum of Korea, National Treasure no. 345

Bottle with a Flowering Plant Design, Goryeo, Porcelain, h. 26.1cm, National Museum of Korea

p.33 Lidded Bowl with Decoration of Floral Medallions and Vines, 12th-13th century, Goryeo, Soft-paste porcelain with inlaid design, h. 2.7cm, National Museum of Korea

Litted Bowl with Decoration of Lotus Petals, Goryeo, Soft-paste porcelain with intaglio design, h. 3.6cm, National Museum of Korea

Chrysanthemum-shaped Lidded Bowl, Goryeo, Soft-paste porcelain, h. 5.1cm, National Museum of Korea

Chrysanthemum-shaped Lidded Bowl, Goryeo, Soft-paste porcelain, OAH. 6cm, National Museum of Korea

inlaid design, h. 23.9cm, National Museum of Korea

p.111 Bottle with Decoration of Cord, 16th century, Joseon, Porcelain, h. 31.4cm, National Museum of Korea, Treasure no. 1060

p.112 Bottle with Decoration of Seven Trasures and Orchid, late 17th-early 18th century, Joseon, Porcelain with underglaze cobalt-blue design, h. 21.1cm, National Museum of Korea, Treasure no. 1058

Octagonal Bottle with Decoration of Chrysanthemum and Bamboo, late 17th-18th century, Joseon, Porcelain with underglaze cobalt-blue design, h. 27.5cm, National Museum of Korea

Bottle with Decoration of Pear Flower, late 19th-early 20th century, Joseon, Porcelain with underglaze cobalt-blue design, h. 20.6cm, National Museum of Korea

p.113 Teapot, 19th century, Joseon, Porcelain, h. 10.1cm, National Museum of Korea, Treasure no. 1058

Teapot with Decoration of Peony, 19th century, Joseon, Porcelain with underglaze cobalt-blue design, h. 19.8cm, Gyeonggi Ceramic Museum

p.114 Burial Figures, 17th century, Joseon, Porcelain painted in underglaze iron-brown, h. 6.6-8.7cm, National Museum of Korea

p.115 Ritual Vessel with Decoration of China Rose, 19th century, Joseon, Porcelain with underglaze cobalt-blue design, h. 9.3cm, Horim Museum

p.116 Placenta Jar and a Memorial Stone, ca. 1485, Joseon, Porcelain, h. 42.5cm, National Museum of Korea

Incense Burner with Cobalt-blue *Geon·Gon·Gam·Ri* Trigrams, 19th century, Joseon, Porcelain with openwork design, h. 115cm, National Museum of Korea

p.117 Ritual Vessel, 17th-18th century, Joseon, Porcelain, h. 10.8cm, National Museum of Korea

p.118 Knee-shaped Water Dropper, Joseon, Porcelain, h. 11.2cm, National Museum of Korea

p.119 Water Dropper with Decoration of Plum Blossoms, Joseon, Porcelain with raised carving technique, h. 5.5cm, National Museum of Korea

p.120 Octagonal Water Dropper with Decoration of the Eight Views of Xiaoxiang, 19th century, Joseon, Porcelain with raised carving technique and underglaze cobalt-blue design, h. 12.6cm, National Museum of Korea, Treasure no. 1329

Water Dropper with Decoration of Cloud and Dragon, Joseon, Porcelain with openwork and underglaze cobalt-blue design, h. 11. 5cm, National Museum of Korea

p.121 Brush Holder with Decoration of Plums and Bamboos, Joseon, Porcelain with underglaze cobalt-blue design, h. 12.7cm, National Museum of Korea

p.122 Bamboo-stem-shaped Brush Holder with Decoration of Cross, 19th century, Joseon, Porcelain with openwork design, h. 12cm, National Museum of Korea

Paper Holder with Decoration of Grapes, late 18th century, Joseon, Porcelain with openwork design, h. 15.8cm, National Museum of Korea

Brush Washbasin, 19th century, Joseon, Porcelain, h. 8cm, National Museum of Korea

p.123 Mountain-shaped Brush Hanger, 19th century, Joseon, Porcelain with underglaze cobalt-blue design, h. 23.5 cm, National Museum of Korea

p.125 Octagonal Jar with Decoration of Plum Blossoms, Seo Kwangsu (designated as Intangible Cultural Heritage of Gyeonggi-do and Master of Korea), 2010, Porcelain with underglaze cobalt-blue design, h. 37cm

p.126 Jar with Decoration of Peonies, Han Ilsang (Master of Gwangju-si), 2011, Porcelain with underglaze cobalt-blue design, h. 85cm

p.127 Octagonal Jar, Kim Jeongok (Important Intangible Cultural Heritage, Master of Korea), 2012, Porcelain, h. 37cm

Jar with Decoration of Persimmon, Lim Hangtaek (Master of Korea), 2013, Porcelain with underglaze copper-red and gold design. h. 51cm

p.128 Moon Jar, Park Buwon (Master of Gwangju-si), 2012, Porcelain, h. 51cm

Bibliography

Historical literature
Bibyeonsa Deungrok (Journal of Bibyeonsa, the Defense Counsil).
Seungjeungwon Ilgi (The Daily Records of the Royal Secretariat of Joseon Dynasty).
Joseon Wangjo Sillrok (Annals of the Joseon Dynasty), National Institute of Korean History, 1955-1977.

Monographs
Bak Byeongseon. *Baekja: the Pure White Heart of Korea.* Paju-si, Korea: Dolbegae, 2002.
Choi Gongho. *An Understanding of the Contemporary History of Korean Crafts.* Seoul, Korea: Jaewon, 1996.
Clark, Garth. *Ceramic Art: Comment and Review 1882-1977.* trans. Shin Kwangseok. Gyeonggi-do, Korea: Mijinsa, 1993.
Gweon Byeongtak. *The Production and Demand for Traditional Korean Ceramics.* Gyeongsan-si, Korea: Yeongnam University Press, 1979.
Hong Heeyu. *A Study of the History of Handicrafts in the Medieval Joseon Period.* Seoul, Korea: Jiyangsa, 1989.
Jeong Donghun. *Contemporary Ceramic Art.* Seoul, Korea: Design House, 1994.
_____. *Methods of Kiln Building and Firing for Ceramists.* Seoul, Korea: Design House, 1991.
Jeong Yangmo. *Korean Ceramics.* Seoul, Korea: Moonye, 1991.
Kang Kyungsook. *A Study of the History of Korean Ceramics.* Seoul, Korea: Iljisa, 1989.
_____. *The History of Korean Ceramics.* Seoul, Korea: Sigongsa, 2000.
Kang Mangil. *A Study of the History of Commerce in the Joseon Dynasty in A Series of Studies on Korean Society.* Paju-si, Korea: Hangilsa, 1984.
Kim Yeongwon. *A Study of Korean Ceramics in Early Joseon Dynasty.* Seoul, Korea: Hakyoun, 1995.
_____. *Joseon Baekja.* Seoul, Korea: Daewonsa, 1991.
Seo Gilyong. *Basic Theory and Practice of Ceramics.* Seoul, Korea: Chohyungsa, 1998.
Asakawa, Takumi. *A Study of the Terms for Korean Porcelain.* trans. by Jeong Myeongho. Seoul, Korea: Kyungin, 1993.
Yi Bokgyu. *Raw Materials of Ceramic Ware.* Paju-si, Korea: Mijinsa, 1991.
Yun Yongi. *A Study of Korean Ceramics.* Seoul, Korea: Moonye, 1993.

Catalogues

Busan Museum. *Flowers and Ceramics*. 2004.

Dukwon Gallery. *A Catalogue of Famous Ceramic Ware of the Joseon Dynasty*. 1992.

Ewha Womans University Museum. *Burial Objects (Myeonggi) and Memorial Stones*. 1978.

_____. *Porcelain with Cobalt-blue Designs of Gwangju Bunwon-ri*. 1994.

Gyeonggi Ceramic Museum. *Bunwon Royal Porcelain I & II*. Seoul, Korea: Yemack, 2009.

Hoam Museum. *An Exhibit of Joseon Baekja I, II, & III*. Samsung Foundation of Culture. 1983, 1985, and 1987.

Incheon Metropolitan City Museum. *Modern Industrial Ceramics*. 2009.

National Museum of Korea. *White Porcelain Jars*. 2010

National Museum of Modern and Contemporary Art. *A Glimpse into Korean Modern Crafts*. Seoul, Korea: Eulal, 1999.

National Treasures 8: Porcelain-Buncheong Ware, compiled by Yangmo Jeong. Seoul, Korea: Yegyeong, 1984.

The Beauty of Korea 2–Porcelain, ed. by Yangmo Jeong. Fine Art Quarterly (Joong-ang Newspaper). 1978.

The Complete Works of World Ceramics, No.19: Joseon Dynasty, compiled by Zauho Press. Tokyo, Japan: Shogakukan, 1980.

The Museum of Oriental Ceramics, Osaka. *Korean Ceramics: The beauty of 500 years*. Osaka, Japan: The Association for Promotion of Art, Osaka, Nikkei Inc., 1988.

Yanggu Porcelain Museum. *The 600-Year-Old Light of Bangsan Baekja of Yanggu*. 2007.

Contributors

Park Sungwook (Park Sungwook Ceramic Research Institute)
Han Ilsang (Dopyoung Kiln, Master of Gwangju City)

Baek Jin
Cho Sinhyun (Cho Sinhyun Ceramic Research Institute)
Chung Yountaeg
Han Jeongyong (Han Jeongyong Baekja Studio)
In Hyunsik (Donong Ceramic Studio)
Jung Jaehyo (Joil Kiln)
Kang Sukyoung
Kim Jeongok (Youngnam Kiln, Important Intangible Cultural Heritage, Master of Korea)
Kim Kyutae (Jiahn Kiln)
Kim Yikyung (Kim Yikyung Ceramic Design Advancements Institute)
Lee Changhwa
Lee Dongsik (Wolcheon Kiln)
Lee Geejo (Leesodo Kiln)
Lee Seunghee
Lee Youngho (Yoosan Kiln)
Lim Hangtaek (Hangsan Art Pottery, Master of Korea)
Nam Hwajin
Park Buwon (Dowon Kiln, Master of Gwangju City)
Park Youngsook (Park Youngsook Kiln)
Seo Kwangsu (Hando Kiln, Intangible Cultural Heritage of Gyeonggido, Master of Korea)

Baeksanga
Cultural Heritage Administration
Dongguk University Museum
Gyeonggi Ceramic Museum
Haegang Ceramics Museum
Horim Museum
Jeonju National Museum
Konkuk University Museum
Korea Ceramic Foundation
L153 Art Company
Lee Eugean Gallery
National Museum of Korea
National Palace Museum of Korea
Woohak Cultural Foundation
Yanggu Porcelain Museum

Index

Korean Craft & Design Resource Book 06

Baekja: Korean Traditional Porcelain

Writing
Choi Kun (Former Director, Gyeonggi Ceramic Museum /
Former member of Cultural Heritage Committee)
Chang Kihoon (Director, Gyeonggi Ceramic Museum)
Lee Jeongyong (Ceramic Studio Sori, Lecturer of Kookmin University)

Advice
Cheon Bokhee (Professor, Seoul Womens University)
Cho Ilmook (Former Research Professor, Dankook University)
Kang Kyungsook (Former Professor, Chungbuk National University)
Kim Jaeyeol (Member, Cultural Heritage Committee)
Park Jonghoon (Professor, Dankook University)

Process Management
Lee Sunyoung (General Manager, Korea Craft & Design Foundation)
Oh Wonsim (Senior Researcher, Korea Craft & Design Foundation)

Translation
Kim Kyongsook

Translation Consultant
Park Shinhee
Stephen Freedman

Editing & Design & Layout
Mijin Publisher

Photography
Seo Heungang
Seon Yumin

Printing
Youngshin Printing & Binding Company

Publisher
Kim Taehoon (President, Korea Craft & Design Foundation)

Korea Craft & Design Foundation
KCDF Gallery, 8 Insadong 11gil, Jongno-gu, Seoul, Korea
5F Haeyoung Bldg., 53 Yulgokro, Jongno-gu, Seoul, Korea
phone: 82-2-398-7900 fax: 82-2-398-7999
www.kcdf.kr

First published in Dec. 24, 2014
Second printing on November 30, 2022

ISBN 978-89-97252-34-3
ISBN 978-89-97252-13-8 (set)